Laconia:
1,200 Tweets
on Film

Laconia:
1,200 Tweets
on Film

Masha Tupitsyn

zero
books

Winchester, UK
Washington, USA

First published by Zero Books, 2011
Zero Books is an imprint of John Hunt Publishing Ltd., Laurel House, Station Approach,
Alresford, Hants, SO24 9JH, UK
office1@o-books.net
www.o-books.com

For distributor details and how to order please visit the 'Ordering' section on our website.

Text copyright: Masha Tupitsyn 2010

ISBN: 978 1 84694 608 0

A CIP catalogue record for this book is available from the British Library.

Design: Stuart Davies

Cover design: Masha Tupitsyn

Printed in the UK by CPI Antony Rowe
Printed in the USA by Offset Paperback Mfrs, Inc

We operate a distinctive and ethical publishing philosophy in all
areas of our business, from our global network of authors to
production and worldwide distribution.

Laconia: 1,200 Tweets on Film

The 1200 tweets that constitute Masha Tupitsyn's Laconia are, each one, an aphorism in a bottle set adrift into the midst of all the other criss-crossing messages that movies and the media universe have spawned and continually and more or less blindly emit. Everything is happening in real time—not recollected in tranquility but intercepted in passing—even when the messages emanate from the deep past or (perhaps) a future around the next bend. It's a collage of the present moment, a continuous and unyielding dialogue, open-ended and alert to the barrage of signals that has become our home.

Geoffrey O'Brien, *The Fall of the House of Walworth: A Tale of Madness and Murder in Gilded Age America, Dream Time, Hardboiled America: Lurid Paperbacks And The Masters Of Noir,* and *The Phantom Empire: Movies in the 20th Century.*

There's something about the way Masha Tupitsyn's mind works – when she addresses gender and film. It's different from how pretty much all other contemporary feminist theorists do it. Amid so much detached deconstruction, Tupitsyn's criticism is refreshingly full of life. Laconia, a document of Tupitsyn's public thoughts on film, is a stream of intimate, immediate, and specific reflections on movies, as well as a broad and sustained interrogation of things like whether we can any longer truly see corporatized cities like LA and NY other than in old movies, how to understand David Lynch's women, and whether there is any real possibility for connection in social media, or for that matter, in watching films.

Jessica Hoffman, Writer and Coeditor of Make/Shift Magazine.

To the late Robin Wood, for whom criticism was a
form of living.
And to my mother and father, who have always given me
emotional and intellectual edification.

There is no need to leave behind an entire film.
8 ½

Exploring The Line

"There is nothing that is major or revolutionary except
the minor."
Gilles Deleuze and Félix Guattari

The twentieth-century architect Mies van der Rohe, whose two
1950 Lake Shore high-rises appear on the cover of this book,
famously declared, "Architecture starts when you carefully put
two bricks together." This tenet of modern design, along with
Mies van der Rohe's other famous precept, "Less is more," has
served as a model for the way I approached the composition of
LACONIA, for on Twitter, a line (140 characters) is all you have
to work with. Unlike visual art or literature, architecture, like
mass media and film, the subject of this book, is part of our daily
experience, or, as the architectural photographer Julius Shulman
put it, "architecture affects everybody." Even the massive and
overpowering skyscraper is an example of the laconic or
elemental if we see it as a brick by brick process. The original
structural definition of the word skyscraper, which was based on
the early see-through steel skeleton frames of skyscrapers (as
opposed to the impermeable reinforced concrete used to build
skyscrapers today), can be taken as another leitmotif running
through this collection. For, *LACONIA* is, in essence, an archi-
tecture of thinking. It is also a book that shows its skeleton. That
tackles the multi-media landscape as a language pattern rather a
material phenomenon.

In some ways, I think I was born to write this kind of book
because for me writing always starts with: a line, a phrase, a
fragment. Modeled on the aphorism, while updating and
tailoring it to film and pop culture, the goal in *LACONIA* was to

zoom in rather than out, to write in close-ups, so that every word, to quote Ezra Pound, could become "charged with meaning." Like the aphorism, which according to James Geary in *The World in a Phrase: A Brief History of the Aphorism*, must be "brief, definitive, personal, philosophical, have a twist," and reveal some larger truth, each tweet in *LACONIA* is a miniature exegesis; an appraisal of the world through film and media since our understanding of the world has become increasingly, if not entirely, shaped and mediated by both.

Given that *LACONIA* has more in common with poetry and prose, with a tradition of compressed writing, it's a book of cultural criticism that also works as a study in the language and Zen-like practice of observation. *LACONIA* doesn't just dramatize the thinking process. It dramatizes the act of thinking *through* film. For me, film isn't simply what I think about or write about, it's the medium through which I discover and articulate what I think. Writer and filmmaker Jean-Pierre Gorin notes a similar preoccupation in Chris Marker's *La Jetée* (1962) and *Sans Soleil* (1982) (two films that have greatly influenced this collection), stating that Marker's work is about "How you put together a thought, a life. How you interact with the elements that are given to you."

As a teenager, I read Roland Barthes' *A Lover's Discourse: Fragments*, Sol Lewitt's essay on conceptual art as mental process, "Paragraphs on Art," and Baudelaire's prose sketches *Paris Spleen*, which have no particular order. No beginning or end. That can be read simply as thoughts. I was also interested in the phraseologies of multi-media artists like Barbara Kruger and Jenny Holzer, whose work blurs the line between the aphorism (subversive, mindful) and the cliché (reductive, mindless), and to whom James Geary coincidentally devotes the final chapter of *The World in a Phrase*, aptly titled, "In the Beginning Was the Word—At the End Just the Cliché: The Aphorism Today." But my interest in laconic style, or minimalist critique, crystallized when

I saw Alfredo Jaar's installation "Lament of The Images" at Documenta XI in 2002. Jaar, a documentary photographer who uses new mediums of representation, and who like Barthes opts to write about images rather than reproduce them, states that with the overproduction of images we've become "oblivious to pictures." This indifference results in what Jaar calls a "blindness effect." Likewise, LACONIA is in part a lament of the over-production of language, a communication overload we're incapable of keeping up with or making sense of. Where non-stop ideas and a cacophony of "innermost" thoughts scattered all over the Web are often likely to be unread and unheard—the proverbial tree in the forest.

In "Lament of The Images" Jaar chooses to make his photo-journalism textual rather visual, offering "the public an alter-native opportunity to reflect and meditate upon the lack of photographs in order to restore their 'lost sight,'" in the same way that I use laconic language, or micro-criticism, to restore (at least for myself) some of the concentration, economy, and attention to language we've lost. The gradual accumulation and evolution of ideas in LACONIA is also an attempt at slowing down the enormous "production" of ideas. While the Internet gives all of us the opportunity to communicate and create, to comment and respond, it's also obscured a more important criterion: What is it that we *need* to say and what is it that we *don't*? What helps us with our work and our life and what distracts us from it? What is necessary and what simply clutters up the world? In other words, how much "art" do we really need? In my case, I avoided tweeting arbitrarily or simply churning out a collection of tweets that would result in a book. Instead, I wrote and crafted each entry as though it was for and part of a book, rather than the other way around. This gave my entries a larger purpose—an essential quality.

LACONIA contains a nexus of themes. Rather than expanding upon one idea at length, it connects the dots, using a hybrid of

sources to build a mosaic of patterns that emphasizes and explores the correlations and juxtapositions between films. "How you put together a thought, a life"—rather than simply an essay or a book—and how you think on a day-to-day basis, in an age that leaves you with very little time or space to do either, is ultimately the focus of *LACONIA*. Put simply, this collection concerns the person, not just the work, for as Joe Baltlake writes on his blog, "The Passionate Moviegoer," "The way a person connects the lines; the way he or she responds to a movie, says a lot about them."

Finally, *LACONIA* resists the bigger is better, more is more, ethos, and instead builds a scope of concerns and subjects with small gestures. As a tangible object made using an immaterial form (Twitter warns users that after 8,000 tweets, their tweets may disappear. Mine vanished temporarily after only a 1,000), *LACONIA* is a physical interpretation of the digital age; the desire to make something tangible and resonant in an increasingly immaterial world. When I first started tweeting, I faithfully adhered to Twitter's 140-character limit—its Haiku-like form— creating aphoristic and self-contained worlds in the allotted virtual boxes. However, over time, I felt the character restriction was limiting, and I began to look for ways around it by experimenting with form and writing longer entries. I broke long posts into multiple entries. Writing a book on Twitter, in the 21st Century, means that certain narrative traditions—the way narrative texts are constructed and consumed, as well as where they are constructed and consumed—have to be challenged redefined. It also meant that *LACONIA*, a literary experiment, had to both honor and break the conventions of Twitter. The Web, along with the advent of Kindle and the Ipad, has meant that writing and reading are no longer happening in the same ways or in the same spaces. *LACONIA* is thus a book that has a dual identity and a dual purpose. It honors both the old and the new. It exists in two places at once and in two different forms. It is a

virtual manifesto and a physical object.

References

1. Almeida, Laura Freitas, "Blindness and Enlightenment in Alfredo Jaar's 'Lament of The Images,'" http://ufsinfron-terasp2010.weebly.com/uploads/2/8/5/1/2851833/laura_freitas_-_afredo_jaar_in_plato.pdf

Masha Tupitsyn
August 9, 2010
New York City

1. Found a VHS copy of *Kramer v. Kramer* in the laundry room last night and watched it. The 1st half is progressive. The 2nd is reactionary.
1:38 PM April 26th 2009

2. I like the way people in the 70s used to show up at the Oscars in casual clothes like they were just going out to dinner.
1:39 PM Apr 27th

3. *Eastern Promises* & *A History Violence* are twin parables: one film looks at violence from the outside in and the other from the inside out.
10:29 PM Apr 28th

4. I hated *Rachel Getting Married*. Can America, obsessed with individualism, make a film about the communal without turning it into communal
7:32 PM Apr 30th

5. hysteria?
7:33 PM Apr 30th

6. In *Let the Right One In*, a boy overcomes his secret death wish/fetish when, like a celebrity, death is stripped of its star qualities.
9:27 PM May 15th

7. "When you were alive, there was still the possibility of being an author & disdaining TV." Erica Jong to Sylvia Plath in *Seducing The Demon*
11:18 AM May 18th

8. Erica Jong, Part 2: "We emphasize personality rather than work in our world. One has to be photogenic, unafraid to chatter with idiots
 2:11 PM May 18th

9. on the screen."
 2:12 PM May 18th

10. In *The Savages* the erosion of the line between onscreen and offscreen is the result of dementia. The senile father can't tell the difference
 10:48 PM May 19th

11. because he can't remember the difference, making our inability to differentiate between reality and representation a form of derangement.
 10:49 PM May 19th

12. On *Oprah*, families are asked to live without TV for one week, only in order to see whether they can, they have to live without TV on TV. So
 3:45 PM May 20th

13. no TV=TV.
 3:46 PM May 20th

14. Who needs a mother and a father in America when you have the media—the 21st Century's true parent.
 12:56 PM May 21st

15. *Wendy and Lucy* seems to be a movie about how much people can endure without ever verbally expressing how painful endurance actually is.
 10:17 AM May 22nd

16. *Love at Large* makes fun of the taciturn male noir driving —
 motionlessly — in his car to nowhere. Particularly James
 Stewart in *Vertigo*.
 10:47 AM May 23rd

17. In *The Castle*, Michael Haneke constantly truncates scenes.
 There is more and more black screen; more and more we
 don't see; less
 7:21 PM May 24th

18. and less confined to the screen; more and more offscreen.
 More and more we don't know.
 7:22 PM May 24th

19. *Lars and the Real Girl* confirms that we're now as genuinely
 moved by fake as we once were by real. Catharsis comes
 in the form of silicone.
 10:45 AM May 25th

20. In *Half Nelson*, the face is landscape. It fills the screen like
 it did in the 70s, when the face was used to comment on
 the social.
 7:30 PM May 26th

21. "If you want to look at the spectators you have to look
 into the camera." Agnès Varda, *The Beaches of Agnès*
 10:50 AM May 27th

22. In *A Very Long Engagement*, Mathilde mourns for her lover
 with her tuba because "the tuba is the only instrument
 capable of imitating a
 1:08 PM May 27th

23. distress call."
 1:09 PM May 27th

24. Facebook is the perfect trope for facade culture. So are
 celebrities.
 2:51 PM May 27th

25. Watched *Broken English*. Finally, a movie about real
 people and real love by the daughter of John Cassavetes,
 whose films are all about love.
 12:39 AM May 28th

26. *Wanted and Desired*, the documentary on Roman Polanski,
 is biased and boring, and only proves what it sets out to
 disprove: that movies are
 11:15 AM May 29th

27. never separate from the people who make them.
 11:16 AM May 29th

28. Sometimes I rent old movies just to look at old New York.
 In *My Winnipeg*, Guy Maddin mourns the same: "At some
 point," notes Maddin, "when
 12:47 PM May 30th

29. you miss a place enough, the backgrounds in photos
 become more important than the people in them." In *Eyes
 Wide Shut* Kubrick obliterates the
 12:48 PM May 30th

30. familiarity of place, making remembering or recognizing
 place impossible. In *Eyes Wide Shut*, the fallout of gentri-
 fication is a
 12:49 PM May 30th

31. psychological phenomenon. Landscape isn't real. It's inside.
 12:50 PM May 30th

32. "Who's alive? Who is alive? Who's alive anymore?" *My Winnipeg*
 11:47 PM May 31st

33. Michael Mann films New York like he films LA. Cities are empty and people, like buildings, stand alone.
 10:50 AM June 1st

34. *Superbad*: Aka, The Return to Phallocentrism? You know, given all the unabashed verbal and visual homages to dick.
 12:01 PM June 1st

35. *They Shoot Horses, Don't They?* is a cross between *No Exit* & Reality TV. People eat, shave, sleep; live and die on the purgatorial
 7:06 PM June 1st

36. "dance" floor.
 7:07 PM June 1st

37. Watched *Talking Heads: Stop Making Sense* again tonight. Amazing. Makes the 80s look like creative sainthood compared to now.
 10:31 PM June 2nd

38. In *Palindromes*, Solondz breaks down the old model of viewer identification by having his female lead switch race, gender, class, body, and
 9:04 PM June 3rd

39. age. But underneath the shifts, nothing actually changes. The alterations are purely cosmetic. The film is deeply deterministic, for despite
9:05 PM June 3rd

40. all the alterations, Solondz doesn't believe people are capable of change. So what then is the difference between the Creationists and
9:06 PM June 3rd

41. Solondz in the movie?
9:10 PM June 3rd

42. Does pro-misery always have to trump pro-choice? Abortion's become so taboo it's no longer even an option—*Juno, Knocked Up, Desperate*
2:33 PM June 4th

43. *Housewives.* In contrast, in *Next Stop, Greenwich Village,* set in the 50s, made in the late 70s, a bohemian, working class woman gets an
2:36 PM June 4th

44. abortion in order to save the life she wants to live, instead of the one she doesn't.
2:37 PM June 4th

45. Erica Jong: "A city where there is no industry but tourism grows cynical." Dan Jinks, producer of *Milk*: "Our great hope is that [*Milk*]
8:18 PM June 5th

46. will revitalize [the Castro] and make it a major tourist destination."
8:19 PM June 5th

47. *Heaven Can Wait* is like the B version of *Being There*. Warren Beatty made *Heaven Can Wait* so that he could make *Reds*. Shirley MacLaine,
2:19 PM June 6th

48. Beatty's sister, starred in *Being There*. Jerzy Kosinski, who wrote *Being There*, was a good friend of Beatty's and plays Grigory Zinoviev in
2:20 PM June 6th

49. *Reds*.
2:21 PM June 6th

50. Watched *Cutter's Way* last night. I've only ever seen it broken into pieces on TV. Is the movie about giving a shit vs. not giving a shit?
2:12 PM June 7th

51. IMDb states that Jeff Bridges could have been the lead in any number of iconic films from *Love Story* to *Jaws*, *Taxi Driver* to *Rambo*, *Fatal*
2:13 PM June 7th

52. *Attraction* to *Big*, *Total Recall* to *Speed*. And instead of Al Pacino and Robert De Niro as the male couplet in Michael Mann's *Heat*, the
2:14 PM June 7th

53. original dyad was supposed to be Jeff Bridges and Nick Nolte. Two blonde WASPs instead of two dark-haired Italians.
2:16 PM June 7th

54. In Michael Haneke's films there is never scapegoating (like in *Crash*, 2004). The dread of the Other (*Caché*) is always about complicity.
3:08 PM June 8th

55. As Hollywood, and the rest of America, scrapes its noses, I think of all the plastic surgeons around the world and this quote from Nikolai
11:08 AM June 9th

56. Gogol's "The Nose:" "I assure you that without a nose you will be as healthy as with one."
11:09 AM June 9th

57. When Jean-Pierre Léaud, playing a French director in Olivier Assayas' *Irma Vep*, a remake of the silent movie serial *Les Vampires*, tells his
7:25 PM June 10th

58. leading actress: "You are more important than the character. There is nothing for you to act," he is confronting his own serial legacy as
7:26 PM June 10th

59. the recurring character Antoine Doinel.
7:27 PM June 10th

60. The beautiful *The Tracey Fragments* shows us that the screen has become total. Frameless and amoebic. Never off, always on, all over. Inside.
11:58 AM June 11th

61. I dreamt that *L'Avventura* was red the way that *Point Blank* is blue.
10:33 AM June 12th

62. How can a voice change so much? Mickey Rourke's old (soft) voice never matched the man. Now it does.
6:16 PM June 13th

63. Everyone claims that *The Wrestler* parallels Rourke's own life. But to me the big difference is the man onscreen is better than the man off it.
6:18 PM June 14th

64. Speaking of the gravitas of voices, with the vocal switch (timbre, tempo, twang, decibel) down went Pacino.
6:26 PM June 15th

65. In the late 60s and 70s, car chases replaced galloping horses.
6:56 PM June 16th

66. I'm going to miss NYC for the rest of my life and maybe LA too because I never got to see it. Movies are a way to get time and place back in
9:09 PM June 17th

67. footage.
9:10 PM June 17th

68. "It gets so bad you up searching an unchanging celluloid surface for a clue to vanished worlds." Geoffrey O'Brien, *The Phantom Empire*
1:00 PM June 18th

69. The star is the anterior of cyberspace. Whatever they say gets blasted into the ether every which way. It's a dangerous way to live.
11:31 AM June 19th

70. Dangerous because the star's life and body are always on the market, making the paparazzi the tracking equivalent of the dow jones.
11:32 AM June 19th

71. How can Maria Bello be in *A History of Violence* AND the new *Rambo*? One appearance totally negates the other.
9:31 PM June 20th

72. In *Happy-Go-Lucky*, happiness doesn't preclude social awareness. Poppy, the remarkable female lead, is nuanced, complex, multi-faceted.
2:24 PM June 25th

73. A complete person, Poppy disproves the prevalent theory that tragedy and dysfunction are the only valid and available narrative options (see
2:25 PM June 25th

74. *Julia*, 2008). What film scholar Robin Wood described as "The striving toward a human completeness" in his *CineAction* essay on the films of
2:26 PM June 25th

75. Michael Haneke.
 2:27 PM June 25th

76. Nicolas Roeg's *Bad Timing* looks at the split between what
 you are with a person and what that person is with you,
 and what you are
 2:39 PM July 3rd

77. without that person and what that person is without you.
 2:40 PM July 3rd

78. "I'll be honest with you. I don't how honest I can be with
 you." *The Interpreter*
 5:43 PM July 7th

79. Watching Theresa Russell's films. When I was little, I
 knew her only as the "maneater" from *Black Widow*, which
 I rented repeatedly
 10:31 AM July 10th

80. when I was ten because I wanted to watch Debra
 Winger—the woman everyone claimed was a "hell raiser"
 in real life.
 10:32 AM July 10th

81. "You believe because you get information out to people
 something happens?" *The Insider*
 2:16 PM July 11th

82. I know that Michael Mann makes movies about men (and
 often they're interesting), but the two principal female
 roles in *The Insider*—the
 2:21 PM July 12th

83. silent, materialistic wife and the silent *60 Minutes* reporter—are pathetic renditions.
2:22 PM July 12th

84. The screen in Elia Kazan's last film, *The Last Tycoon* (1976) turns into a sea of consciousness; a black hole that's not just life-as-screen,
8:51 PM July 13th

85. but world-as-screen. The allegorical movie screen swallows De Niro whole at the end, the way the whale swallows Jonah in Jonah and The Whale.
8:52 PM July 13th

86. "Dude, there's blood," *Harper's Island*. Colloquialism triumphs over horror.
8:15 PM July 14th

87. "How are we supposed to find anyone in all this nature?" *Harper's Island*
10:39 PM July 15th

88. It turns out *Harper's Island* is an anti-adoption story. So Madonna and Angelina, watch out.
7:49 AM July 16th

89. In *The Chase*, Robert Redford and Jane Fonda are lit like sunflowers at night in the film's junkyard coda.
10:18 AM July 17th

90. Robert Downey Jr. is beautiful in *The Pick-Up Artist* because he is so masculine/feminine. Because he is such a clown.
10:48 PM July 18th

91. In Oprah's 1993 interview with Michael Jackson, it's clear that in America journalists pretend to ask real questions and celebrities pretend
5:36 PM July 19th

92. to give real answers.
5:37 PM July 19th

93. If you compare old/shallow Oprah to new/sage Oprah, you can see that in America depth is a media invention. A part you can start playing at any point.
12:26 PM July 20th

94. "What was logical or right didn't matter anymore. This was a different kind of world now." The Child, Sarah Schulman
4:40 PM July 21st

95. On an online discussion board about Michael Jackson's memorial service, someone asks: "If we're incorrect for 'judging' someone we
3:36 PM July 22nd

96. don't know, aren't we just as incorrect for praising someone we don't know?'"
3:37 PM July 22nd

97. What's interesting about the rebellion in Caged Heat (1974) is how indebted its rebellion is to time. 35 years later, technology has
11:04 AM July 23rd

98. made escaping virtually impossible. If cell phones had been around in 1974, those caged girls would have never broken free.
11:05 AM July 23rd

99. I know there was Jonathan Demme, Ron Howard, Martin Scorsese, and Peter Bogdanovich, but did Roger Corman ever apprentice any women?
7:53 PM July 24th

100. Why is the self-proclaimed "very private" John Cusack on Twitter? I wonder if I should tell him that I'm writing a book about him? I
1:49 PM July 25th

101. better not. He might try to sue me. Despite all of his denials, I think Cusack is profoundly tied to his own screen mythology.
1:50 PM July 25th

102. "I think privacy is dead. It's like it's had its knees already cut out from it and it's just a matter of when the body falls." CEO of Technorati
2:10 PM July 26th

103. I just can't bring myself to watch *Changeling* or *Wanted* because looking at Angelina Jolie's already-dead face is like looking at
2:19 PM July 27th

104. Damien Hirst's diamond encrusted skull.
2:20 PM July 27th

105. In the movies, you can see New York in a way that you can't see Los Angeles.
5:23 PM July 28th

106. John Williams' *Witches of Eastwick* score is full of *Jaws*. Williams couldn't forget the shark. It swims around in everything he did afterwards
10:02 PM July 29th

107. (see *Superman*, 1978). And Daryl Van Horne's whistling in the ice cream shop in *Eastwick*, which is actually Williams whistling, sounds
10:06 PM July 29th

108. exactly like Quint's eerie whistle aboard the Orca in *Jaws*.
10:07 PM July 29th

109. It's typical that when it comes to Twitter celebrities grovel to fans to get them to follow them in order to reach a goal number
3:08 PM July 30th

110. —a million followers for Ashton Kutcher or 20,000 for the new-to-Twitter John Cusack. And yet celebrities only follow other celebrities.
3:09 PM July 30th

111. Fans stay at the bottom and stars stay at the top. Only now celebrities pretend to "reach out." Or, as one Twitterer @KevinAlban humorously
3:10 PM July 30th

112. put it: "Twitter: Enabling celebrities to fight back since 2006."
 3:11 PM July 30th

113. Recently, Conan O'Brien had the over-exposed Seth Rogan on and said, "I can't believe you wrote *Superbad* when you were 13." I can.
 3:20 PM July 31st

114. In *Becoming Jane*, which I didn't really like, but which made me weep, the best scene occurs at the ball, when Jane desperately scans the room
 2:44 PM August 1st

115. for Lefroy, believing he's not in attendance, until he suddenly appears in the frame by slipping into the French contra line dance when Jane
 2:45 PM Aug 1st

116. isn't looking (but we are). The moment is all about the face as romantic trope. The face, and how it appears in the frame, is beautiful mise-
 2:46 PM Aug 1st

117. en-scène. McAvoy's face changes everything in a matter of seconds, which is no easy task. Think Brad Pitt could ever pull that off? In
 2:47 PM Aug 1st

118. the unbearable *The Curious Case of Benjamin Button*, Brad Pitt has how many years and all kinds of effects to convince us
 2:53 PM Aug 1st

119. he loves Daisy, and yet I never believed it.
2:54 PM Aug 1st

120. Nicholas Roeg's film *Witches* is half comic-feminist parable half indictment of single women who shun reproduction.
10:31 AM Aug 6th

121. While watching *The China Syndrome*, I stumbled upon a realization: Michael Douglas didn't always act like a pig onscreen. That took time.
10:34 PM Aug 7th

122. When Douglas, who also produced *The China Syndrome*, calls Jane Fonda an "asshole" it's so much fairer than the usual and
10:36 PM Aug 7th

123. predictable "bitch." Both the scene and the relationship are transformed by word choice.
10:37 PM Aug 7th

124. Teen runaway movies are interesting because of their depiction of World. In capitalist, bourgeois society, the world is the goal, but in
6:24 PM Aug 8th

125. runaway films it is something to flee.
6:25 PM Aug 8th

126. For philosopher Peter Sloterdijk oil gushing from a well symbolizes 20th C. modernism. Oil and blood are interchangeable. *There Will Be*
10:47 AM Aug 9th

127. *Blood* can thus be read as a companion piece to *The Shining*, where blood gushes from the well of American capitalism, which is the haunted
10:49 AM Aug 9th

128. Overlook Hotel. Elevator doors snap open and a river of blood pours out.
10:50 AM Aug 9th

129. *Two Lovers* is pure Shiksa hysteria. Is Leonard's (Joaquin Phoenix) bi-polarity code for self-hating Jew?
11:33 AM Aug 10th

130. In situations where you are not allowed to be human—because of your race, class, gender, sexuality; because you are a foreigner, an
2:39 PM Aug 11th

131. "illegal," an invisible—you are *not* human. I was struck by this while watching the anonymous, Kosovonian "lady beggar" (in Michael Haneke's
2:40 PM Aug 11th

132. *Code Unknown*) in Paris transform into someone real and tangible again—someone valuable—when she returns to her family in a war-torn
2:41 PM Aug 11th

133. Kossovo. In this world, context determines worth.
2:42 PM Aug 11th

134. Walking home, I thought about what Pacino said on *Inside the Actor's Studio*—how getting upset is easier to act than to actually feel. And
10:57 AM Aug 12th

135. then I remembered this movie quote: "The masking smile is easy to fake."
10:58 AM Aug 12th

136. "Acting is like a Halloween mask that you put on. I like to pretend." River Phoenix.
12:47 PM Aug 13th

137. Turner Classic Movies finally makes it to the 60s & 70s. *The Comedians* and *Marooned,* whose color palette looks like a box of crayons.
12:29 PM Aug 14th

138. Has Gene Hackman only ever been one age? He has never looked young. Not even in 1963, the year he made *Lilith.*
6:26 PM Aug 15th

139. Eastwood in *Gran Torino* and Nicholson in *As Good as It Gets* are in some ways the same man. Just substitute "fish head" for "fudgepacker."
1:25 PM Aug 16th

140. *The History Boys* complicates the pedagogical in interesting ways by bringing (queer) desire not only into the classroom but also into the teacher.
1:28 PM Aug 17th

141. I think what happened to Christian Bale happened to Mel
 Gibson. Both actors lost their talent (and their sanity)
 when they turned into
 2:03 PM Aug 18th

142. "Americans."
 2:04 PM Aug 18th

143. Saw *The Sugarland Express*. Makes sense that *Jaws* came
 next. The blurry long shots and cold blues prefigure the
 ocean, and the media is the
 10:52 AM Aug 19th

144. shark.
 10:53 AM Aug 19th

145. "Their emotions walk away. Their minds walk away.
 Everything they say to you walks away. Their promises
 walk away." On men, *Gas Food Lodging*
 8:21 AM Aug 20th

146. So many 70s American films have a drum beat to them. A
 march. A sense of conspiracy and ideological tension. As
 film scholar Robin Wood
 10:28 PM Aug 21st

147. put it: "In the 70s, the definition of normality became
 increasingly uncertain...open to attack."
 10:29 PM Aug 21st

148. I think Hal Hartley's early films are a kind of American,
 English-language translation of the French New Wave.
 12:07 AM Aug 22nd

149. "I avoid situations in which I have to talk to anyone's press agent (This precludes doing pieces on most actors, a bonus in itself)." Joan Didion
9:16 PM Aug 23rd

150. Robert Redford is interesting, mostly because of how withholding and tentative he is—as an actor; as a character. His withholding is
1:45 PM Aug 24th

151. everything. His roles onscreen seem to be about one thing: what he doesn't do, what he doesn't say, what he doesn't show. And yet, Elliot
1:46 PM Aug 24th

152. Gould is just as inscrutable. Don't let his chattiness fool you.
1:47 PM Aug 24th

153. In *Pola X*, the love story you write is not the love story you live.
9:15 PM Aug 25th

154. The premise of *Eternal Sunshine of the Spotless Mind* lies in *Zabriskie Point*, where Daria fantasizes: "It would be nice if they could plant
4:47 PM Aug 27th

155. thoughts in our heads so nobody would have bad memories. We could plant wonderful things we did, like a happy childhood...Only good things."
4:48 PM Aug 27th

156. Watched the awful *Ghosts of Girlfriends Past* on my flight to Italy. Is Michael Douglas' satyr based on the notorious Hollywood producer Bob Evans?
5:40 AM September 1st

157. I think *The Yakuza* (1975) might be Paul Schrader's only non-psychotic, or least psychotic, script.
5:41 AM Sep 2nd

158. In Florence, I thought of *Hannibal* and the fake antiquity City it depicts onscreen. Makes the now chintzy Florence look like it isn't falling
9:06 PM Sep 11th

159. to pieces. There's simply no way an "aesthete" like Hannibal would ever choose to live there now. Florence today reminds me of a fake Gucci
9:10 PM Sep 11th

160. bag. When there are too many tourists, beautiful cities start to look cheap.
9:12 PM Sep 11th

161. Now I think John Williams stole Claude Debussy's *La Mer* for *Jaws*. Harps to signify being underwater.
10:21 AM Sep 12th

162. The last thing I usually want to do is watch a movie with someone.
11:30 AM Sep 13th

163. The only place where a break up still matters, where people are allowed to be upset about their breakups, is the movies.
10:10 AM Sep 14th

164. *Eureka* starts off looking like a snow globe. The motif of snow echoes the motif of water in *Don't Look Now*.
9:36 AM Sep 15th

165. "They despise you because you have me and they haven't and I'm worth having." Teresa Russell in Nicolas Roeg's *Eureka*
11:54 PM Sep 15th

166. In *Eureka*, Jack McCann strikes eureka—not gold—and eureka means coming face to face with something, which signals the beginning or the end
1:23 PM Sep 16th

167. of what could be.
1:24 PM Sep 16th

168. "What did people do, anyway, before there were movies? They studied the rate at which things changed." *The Phantom Empire*
3:09 PM Sep 17th

169. I am looking for Ken Russell/Teresa Russell's *Whore*. And *Luna*, and *Ash Wednesday*.
10:10 AM Sep 18th

170. As people, can we get beyond perpetuating this binary: The writing is better than the person or the person is better than the writing?
6:43 PM Sep 18th

171. In *Notes On a Scandal*'s special features, Blanchett, Dench, & Nighy throw the word "loneliness" around as a fake descriptive trope to mask
11:35 AM Sep 20th

172. the film's hysterical homophobia. Not a word about how Dench's Barbara "Covett" is a lesbian, only that she's "evil." The silence turns into
11:37 AM Sep 20th

173. the story of a "predatory dyke/witch" whom Blanchett's Sheba must escape only to be saved by the warm embrace of heteronormativity. But if
11:38 AM Sep 20th

174. Blanchett's Sheba can lust after a younger boy, and is married to a man twice her age, why can't Dench's Barbara lust after a younger woman?
11:39 AM Sep 20th

175. "How does a girl like you get to be a girl like you?" *North by Northwest*
2:59 PM Sep 20th

176. On Turner Classic Movies tonight, the set designer talked about how Cary Grant and Eva St. Marie both thought the script for *North by*
3:38 PM Sep 20th

177. *Northwest* was too suggestive. Lots of dubbing ensued as a result. "Make love" became "discuss love."
3:39 PM Sep 20th

178. Movies made about the 80s in the 80s (*Less Than Zero*) and movies made about the 80s today (*The Informers*) share the same basic thing in
9:08 PM Sep 21st

179. common: people can't handle much of anything, which then makes them do deplorable things, which is the worst kind of handling. You can be inside
9:12 PM Sep 21st

180. a time or you can be outside a time. Perspective seems to change nothing.
9:13 PM Sep 21st

181. For some reason I was obsessed with *Against All Odds*—a remake of the noir *Out of the Past*—as a kid. I think it had something to do with
3:13 PM Sep 22nd

182. Jeff Bridges. The way he emotes. His tan skin, the clothes he wore. The way he suddenly flips emotions on that seem irreversibly dormant.
3:14 PM Sep 22nd

183. *Altered States* has the best alien-landing scene I've ever seen. William Hurt standing in the white-light doorway as he arrives at a 60s NY party.
7:14 PM Sep 23rd

184. "I love beauty the way I love a beautiful lady, a beautiful dog, a beautiful piece of furniture. It's not my fault." Valentino Garavani
11:23 PM Sep 23rd

185. In the *Valentino* documentary, men in dresses, who sleep
 with men, say they had hard-ons from looking at women
 in dresses made by men. And
 11:32 PM Sep 23rd

186. in Peter Greenaway's reworking of Fellini's *8 ½*, *8 ½*
 Women, Storey, a man, tells Simato, a woman: "You have
 no right to be jealous of a
 11:33 PM Sep 23rd

187. woman who wants to be more of a woman by watching a
 man dressed up as a woman."
 11:34 PM Sep 23rd

188. The end of the *Valentino* documentary is like *The Stepford
 Wives* (1975) with dresses. A wall of upright gowns can be
 creepy too.
 10:39 AM Sep 24th

189. Valentino: "I know what women want: They want to be
 beautiful." Now we know.
 11:04 AM Sep 24th

190. *Night at the Museum 2: Battle of the Smithsonian*, which I
 saw on a plane, is a signifying mess. A paean to a culture
 of non-differentiation.
 3:23 PM Sep 24th

191. Jerzy Kosinski's 1968 novel *Steps* foreshadows today's
 economy and the money we never see—a trademark of
 corporate capitalism. John Boorman's
 11:27 AM Sep 25th

192. 1967 *Point Blank* also explores the idea of phantom money. Lee Marvin's Walker can't get over the fact that the filthy rich tycoons
 11:28 AM Sep 25th

193. who owe him money, never have a cent on them.
 11:28 AM Sep 25th

194. "Pop backwards spells money." Gary Walker from The Walker Brothers.
 12:00 PM Sep 25th

195. "I started to work. I started to work. I started to work" (*The Bad and The Beautiful,* 1952) became "All work and no play makes Jack a
 2:26 PM Sep 25th

196. dull boy" (*The Shining,* 1980).
 2:26 PM Sep 25th

197. Film scholar Andrew Britton points out that in the 80s the body was born again. This makes me think of Jane Fonda's 80s reincarnation
 11:23 AM Sep 26th

198. as a fitness guru.
 11:24 AM Sep 26th

199. In *Pan's Labyrinth* (a loose remake of *The Spirit of The Beehive,* 1973), Ofelia invents a terrifying fantasy to cope with an even more
 8:58 PM Sep 27th

200. terrifying reality.
8:59 PM Sep 27th

201. After years of watching fake movie lives maybe movie life is now more real than real life.
12:47 PM Sep 28th

202. "Movies provided an education in time. Events could be dated by which actors were still alive or by how many wrinkles they had acquired.
9:15 PM Sep 29th

203. Movies made the way real people got old—in linear order and more or less at the same rate—seem clunkily old-fashioned." *The Phantom Empire*
9:16 PM Sep 29th

204. Part of me thinks that *Benjamin Button*, a movie about time, is really an exercise in star fetishization. While Benjamin Button grows
11:04 AM Sep 30th

205. younger, and Brad Pitt grows older, viewers hungrily anticipate the celluloid rewind to Pitt's "beauty." It's no coincidence that his
11:05 AM Sep 30th

206. "beauty" happens to coincide with the aestheticism and iconicism of the 1950s (the eroticization of the male star). Thus the 1950s creates
11:06 AM Sep 30th

207. the perfect conditions for an homage: Brad Pitt, the star, Brad Pitt, the ad; Brad Pitt as James Dean; Brad Pitt as pin-up; Brad Pitt the
11:07 AM Sep 30th

208. matinee idol; Brad Pitt as glamour, as ultimate screen fetish. However, the moment the clock strikes Pitt's "beauty" (and Cate Blanchett's),
11:07 AM October 1st

209. reveling in its magic hour (sunset sailing), is the exact same moment Pitt's own real-life decay starts to show. So that what's supposed to
11:08 AM Oct 1st

210. be the apotheosis of youth and beauty and time is actually the decline of all three—and only film, a record of the star, can do that.
11:09 AM Oct 1st

211. Director Mike Nichols once said: "I think people try to become famous because they think: If you can get the world to revolve around you,
2:37 PM Oct 1st

212. you won't die." Years later, actor William Hurt confirmed Nichols' theory by stating: "When you are a kid you are beset by fears and you
2:38 PM Oct 1st

213. think, I'll solve the fear by living for ever and becoming a movie star.'"
2:39 PM Oct 1st

214. "Actors are never 'who they are.'" *The Lives of Others*
11:52 AM Oct 2nd

215. In *Bluets*, Maggie Nelson writes: "Image replaces the memory it aimed to preserve." In *The Curious Case of Benjamin Button*, CGI plays a
12:33 PM Oct 3rd

216. definitive role as it preserves time (memory) by erasing the materiality of the face altogether. At their youngest (synchronized peak), Daisy and
12:36 PM Oct 3rd

217. Benjamin's ethereal CGI faces recede and resist materializing on film. So that their artificial visages contain nothing, and as *The Sound of Music*'s lyric
12:40 PM Oct 3rd

218. informs, "Nothing comes from Nothing/Nothing ever could."
12:42 PM Oct 3rd

219. At a talk on the film critic Manny Farber the other night, the writer Greil Marcus noted that Farber "stopped the movie with his eyes,"
11:35 AM Oct 4th

220. building suspense that a movie may or may not have had.
11:35 AM Oct 4th

221. In *The Passenger*, color marks breaks in time; ties with time. The body in and out of time. In *Zabriskie Point*, Mark tells Daria, "Once I
1:58 PM Oct 4th

222. changed my color, but it didn't work so I changed back."
1:59 PM Oct 4th

223. There's a synth score running through Peter Weir's *Gallipoli* (set in 1919) that I know I've heard in a Dario Argento movie. But which one and
3:03 PM Oct 4th

224. is this possible?
3:04 PM Oct 4th

225. Film scholar Steven Shaviro reflects on the theme of gentrification in Todd Haynes' *Safe*: "If the first half of the film contemplated the
5:55 PM Oct 4th

226. horrors of outer suburban space, the second half renders visible something much harder to see: the real estate development, as it were,
5:56 PM Oct 4th

227. of inner, psychological space."
5:57 PM Oct 4th

228. After years of being killed by men, films like *Antichrist* and *Downloading Nancy* insist that women want to be murdered, and if men won't do it,
3:19 PM Oct 5th

229. women will make them. Beg them. And if men won't do it to them, women will do it to themselves. That's where the power struggle lies
3:20 PM Oct 5th

230. today. Women fighting to the death for their death.
 3:21 PM Oct 5th

231. "I'm just a dark guy from a den of iniquity. A dark
 shadowy figure from the bowels of iniquity. I wish I
 could be 'Mike' who gets an
 12:36 PM Oct 6th

232. endorsement deal. But you can't make a lie and a truth go
 together. This country wasn't built on moral fiber. This
 country was built on
 12:37 PM Oct 6th

233. rape, slavery, murder, degradation, and affiliation with
 crime.'" Mike Tyson on America and himself
 12:37 PM Oct 6th

234. "What am I here?...I spend my life between the kitchen
 and my bedroom. Is that living in France?" *The Black Girl
 of,* 1966
 1:47 PM Oct 7th

235. Michael Haneke's *The Piano Teacher* and Catherine
 Breillat's *The Last Mistress* are looking at the same thing.
 Only Haneke pushes in and
 10:40 AM Oct 8th

236. Breillat pushes out.
 10:40 AM Oct 8th

237. Brian De Palma's *The Black Dahlia* is the wrong kind of
 fast. Noir was fast, but this is fast *now* trying to make
 sense of fast *then*. Every
 11:31 PM Oct 9th

238. scene is cut wrong. Hacked at, gutted. In *The Black Dahlia*,
De Palma disembowels film noir and film in the same way
that the Black Dahlia's
11:32 PM Oct 9th

239. body was literally emptied out. And the inert Josh Hartnet
has the charisma of a brick. The guy doesn't move. He's
the opposite of the totally
11:33 PM Oct 9th

240. kinetic Ryan Gosling.
11:34 PM Oct 9th

241. Bulgaria, the new shooting locale for Hollywood, repre-
sents the everywhere and always of America. The any
place, any time of it.
5:58 PM Oct 9th

242. "I can't understand how it's possible to live your whole
life without someone and be doing more or less okay and
then suddenly you find them
8:00 PM Oct 11th

243. and you recognize them." *The Eyes of Laura Mars*
8:01 PM Oct 11th

244. "What does it matter what you say about people?" *Touch
of Evil*
10:32 PM Oct 12th

245. In *Touch of Evil*, light is used like a sundial or a justice
scale. It's always tipping and moving and changing and
receding according to the
9:03 PM Oct 13th

246. moral/amoral universe being portrayed onscreen. The light in *Touch of Evil* does not stand still. It also irreverently covers up and obscures
9:04 PM Oct 13th

247. its stars. In other words, light, *in Touch of Evil*, is demarcation. A line you don't cross.
9:05 PM Oct 13th

248. "Charlie Chaplin, F.W. Marnau, Fritz Lang, Ernst Lubitsch, Raoul Walsh, Josef von Sternberg, King Vidor, John Ford, Buster
9:57 PM Oct 14th

249. Keaton. The movies they made were a response to other movies: a dream replying to a dream." Geoffrey O'Brien, *The Phantom Empire*
9:58 PM Oct 14th

250. In *The Eyes of Laura Mars*, photographer Guy Bourdin is turned into a middle aged white woman and the male gaze becomes the only gaze a woman
9:49 AM Oct 15th

251. can have. Laura Mars' photographic practice is so steeped in the male (phallic) point of view and male discourse of vision that she even
9:50 AM Oct 15th

252. sees murder through male eyes. Sees what the killer sees. When Laura herself is pursued by the killer, "She sees through the eyes of the
9:50 AM Oct 15th

253. killer." She views herself in the third person, from behind, as Other; "Stalked from some hidden vantage point... [Laura's] mind and body
9:51 AM Oct 15th

254. seem almost 'inhabited' by a male double.'" *American Horrors: Essays on the Modern American Horror Film*
9:52 AM Oct 15th

255. "If you meet your double, you should kill him." Alfred Hitchcock
9:16 PM Oct 16th

256. The male I/eye is everyone's eye. The female I/eye is her own.
1:11 AM Oct 17th

257. For the 19th Century Leopold in *Kate & Leopold,* time travel into the early 21st Century is merely a way of getting the 21st Century Kate
11:51 PM Oct 18th

258. to return to her 19th Century past. The movie is a fight over time, which of course is always gendered. History doesn't happen without people,
11:52 PM Oct 18th

259. or rather, it doesn't happen, can't happen, without men.
11:53 PM Oct 18th

260. In Hollywood movies, people give up their favorite houses because it's easy to get them back. Easy to get everything back.
9:31 PM Oct 19th

261. On today's *Oprah* the Vuzix Wrap 310, a movie screen that looks like a regular pair of sunglasses, is unveiled. It's official: movies have
 5:43 PM Oct 20th

262. been turned into a pair of eyes we can wear over, or instead of, our own eyes.
 5:43 PM Oct 20th

263. *Before the Devil Knows You're Dead* (Sidney Lumet's latest) is nightmare for the sake of nightmare.
 6:03 PM Oct 21st

264. If insanity is doing the same thing over and over again and expecting a different result, then the continued desire for fame is insanity.
 7:14 PM Oct 22nd

265. Scorsese's religious procession in *Mean Streets* comes from *La Strada* and *Raging Bulls'* Jake La Motta comes from Anthony Quinn's Zampanò.
 11:53 AM Oct 23rd

266. The music/musicianship documentary *It Might Get Loud* is creative macho. Not to be confused with other machos.
 11:55 AM Oct 24th

267. As a song lyric city, I can't get LA out of my head. I could spend months thinking about it without actually ever being able to live there. A
 4:08 PM November 1st

268. byproduct of the cinematic imagination and landscape, Los Angeles is the definition of uncanny. I feel like I have always and never seen it.
4:09 PM Nov 1st

269. In addition to other things, the Dracula narrative is about susceptibility.
8:11 PM Nov 2nd

270. "People were lonely in a way that we aren't now." Jocelin Donahue, star of the horror film *The House of the Devil*
1:00 PM Nov 3rd

271. Why is it that these days the "smartest" people have the blankest faces? As though intelligence were something one contrives rather than possesses.
8:02 AM Nov 4th

272. I know that *Stardust Memories* is an homage to Fellini's *8 ½*, but I actually think that most of Woody Allen's movies are some version of *8 ½*.
9:01 PM Nov 5th

273. Suzanne Moore on David Lynch's representation of women and sexual politics: "To complain or even to raise questions about Lynch's treatment
11:50 PM Nov 6th

274. of women means you have been caught in the Lynch mob's favorite noose. 'Oh, God, you didn't take it seriously, did you? How frightfully
11:51 PM Nov 6th

275. unhip to think a scene about torturing women is really ABOUT torturing women...' I wouldn't ask [Lynch] for sanitized sexual politics, yet
11:52 PM Nov 6th

276. he constantly refuses to analyze what he is doing...Thus he pulls off the remarkable feat of being both the ultimate auteur and yet somehow
11:52 PM Nov 6th

277. not responsible for the content of his work. So who is responsible?...What bothers me about Lynch is that the innate deathwish of the
11:53 PM Nov 6th

278. American Dream is carried out literally on the bodies of women...Like the surrealists. However, Lynch uses women to represent the
11:55 PM Nov 6th

279. unconscious itself... What once looked like a critique of sexual relations between men and women, now looks more and more like a superbly
11:56 PM Nov 6th

280. constructed reinforcement of them. Sadism and masochism may underlie all our relationships, but Lynch is not interested in asking why. Evil
11:57 PM Nov 6th

281. is not explained socially, but in morally vague terms as a presence 'out there in the woods.'"
11:58 PM Nov 6th

282. The theme and motif of the (female) unconscious—the "out there in the woods"—is fully rendered and brought to the surface in Lynch's *Inland*
12:07 AM Nov 7th

283. *Empire*, when the gypsy/clairvoyant (Grace Zabriski) shows up at Niki's (Laura Dern) mansion to forecast what is essentially the plot of the
12:08 AM Nov 7th

284. "cursed" movie Nikki's going to remake, and which is also the plot of *Empire*. The story sounds like something preternatural. Old world.
12:08 AM Nov 7th

285. A story out of Brother's Grimm. Movies are likened to horror and allegory. Women, in Lynch's view, haunt the world, genres haunt other
12:09 AM Nov 7th

286. genres, and cinematic history is a dark path in the fairytale forest, for the proverbial story of the little girl at market is
12:10 AM Nov 7th

287. simply an older version of Niki's story in *Empire*.
12:10 AM Nov 7th

288. "Nothing can be done all over again." *Anatomy of Hell*
12:16 AM Nov 8th

289. I watched *Anatomy of Hell* last night and thought: the world is full of gaps. The gap between what you know and don't know, what you know and
2:28 PM Nov 8th

290. what you do, what you see and what you think, what you say and what you feel, and in Catherine Breillat's *Anatomy of Hell*, the intimacy
2:30 PM Nov 8th

291. you experience and then resist acknowledging as intimacy (even when it happens), thus inevitably reinstating, forfeiting, and perpetuating
2:31 PM Nov 8th

292. that ideological and perceptual gap all over again, even after you've managed to briefly transcend it.
2:32 PM Nov 8th

293. You know movie theater drinks are expensive when Mel Gibson complains about the price of water right in front of you, which happened
8:09 PM Nov 8th

294. tonight at the Angelika film theater in NYC after I saw *The House of the Devil*.
8:09 PM Nov 8th

295. If there's anything interesting about the awful "documentary" *Michael Jackson: The Trial and Triumph of The King of Pop* it's that
11:16 PM Nov 8th

296. celebrity sycophants (fans) are often as crazy, hysterical, and brainwashed as religious zealots. In fact, that's exactly what they are.
11:17 PM Nov 8th

297. The only remakes I ever really want to see are film noirs, and sometimes horror. Not because they're necessarily good, but because noir and
10:17 AM Nov 9th

298. horror are about unfinished business (the repressed); about inexorability. Therefore it makes sense to return.
1:18 AM Nov 9th

299. *The House of The Devil* is the perfect example of image capture applied to genre. The look of a certain period of fear and isolation in
1:30 PM Nov 9th

300. America. The only fresh thing the film truly has to offer is the loneliness—low pitch—we've lost, or covered up, or replaced, but that
1:35 PM Nov 9th

301. also allowed us to recognize and escape horrors. The horror genre shows horror as concrete. Something you come into direct confrontation
1:35 PM Nov 9th

302. with. In *The House of The Devil*, Samantha is not just the Final Girl, she's the only girl. The film is also a micro-history of fear; the way
1:36 PM Nov 9th

303. fear has evolved in capitalism.
 1:37 PM Nov 9th

304. Michael Haneke's sadomasochistic Erika in *The Piano
 Teacher* is a modernization of the 19th C. Karin in
 Bergman's *Cries and Whispers*, who,
 12:42 AM Nov 10th

305. like Erica, cuts her own genitals to relieve (and *feel*) the
 pressures of entrapment.
 12:43 AM Nov 10th

306. Until quite recently I don't think I really understood what
 actors we all are. I believed some people were actually
 still real.
 2:18 PM Nov 11th

307. All of Elia Kazan's films are about being corrupted
 because he himself had been corrupted.
 10:53 PM Nov 11th

308. The documentary *Herb & Dorothy* is art as love story. It's
 also an archive of a bygone world and a bygone people.
 11:02 PM 11th

309. John Cusack on *2012*: "I think more that it's, instead of
 people actually dying in *2012*, I sort of see those things as
 metaphors for
 11:52 PM Nov 11th

310. consciousness, or ways of being, so maybe [it will be] an
 epochal end but it's an epoch of materialism or
 something. [This] sort of savage
 11:53 PM Nov 11th

311. capitalist, me-first thing. Maybe some new era. Something will shift, or something's going to die, and this new thing will begin. So I think
11:54 PM Nov 11th

312. humans will still be stuck with each other, and the world will be a mess, but I hope it doesn't end."
11:55 PM Nov 11th

313. People only say (or think it's good that) someone's work is "scathing" when it's not. Because when it really is, or sets out to be, people
11:17 PM Nov 12th

314. don't want it to exist.
11:18 PM Nov 12th

315. I always have the following lines and lyrics in my head: Morrissey's: "For once in my life let me get what I want," and Delmore
11:29 PM Nov 12th

316. Schwartz's: "I was good but became evil because I expected too much of other human beings," and *The Fisher King's*: "He was sick with
11:30 PM Nov 12th

317. experience," and Rebecca Brown's: "What was true is it was how you were born. If you had what it took if you had the right look. If
11:31 PM Nov 12th

318. someone you knew knew someone who owed a favor. If
 it came easily if you assumed if you acted like you owned
 the place (because you did)
 11:33 PM Nov 12th

319. and by the time you came along things had been like that
 for a long long time and were going to stay that way and
 you could slip right in
 11:34 PM Nov 12th

320. where there was a place for you," and Sapphire's: "First
 it's the culture, but then [people] cooperate with the
 culture and become horrific."
 11:36 PM Nov 12th

321. As John Cusack comes out with *2012*, it's also the 20th
 anniversary of his masterpiece *Say Anything*. To celebrate,
 a *Say Anything*
 11:57 AM Nov 13th

322. mob invades NYC today, as thousands of Lloyd Doblers
 line the streets with boom boxes.
 11:58 AM Nov 13th

323. *The Wizard of Oz* is on TV after I spent the entire day
 singing, "If I only had a brain" to myself.
 8:39 PM Nov 13th

324. "Postmodern irony means never having to say you are
 sorry. Or that you are serious." *Looking for Trouble*,
 Suzanne Moore
 9:29 AM Nov 14th

325.　　I'm still thinking about *The House of The Devil*. I now think it's also a movie about nostalgia for fear. An unselfconscious and unflexive
11:27 AM Nov 14th

326.　　fear that's impossible in today's culture of postmodern irony and affectation. *House of The Devil* looks at fear and genre much like *Scream*,
11:28 AM Nov 14th

327.　　only without the irony and cynicism. Without *wanting* or *expecting* to die. Before you imagined you would or could. *House of*
11:34 AM Nov 14th

328.　　*The Devil* looks at stories and scenarios we already know in order to pretend we *don't* know them, and it does this so that we can
11:35 AM Nov 14th

329.　　imagine or stage a kind of unmediated innocence again. In this case, horror as a genre becomes a statement about and longing for
11:35 AM Nov 14th

330.　　cultural guilessness. For not expecting or wanting the worst thing to happen.
11:36 AM Nov 14th

331.　　Ironically, it's through the worship of Joe Dallesandro's beauty in Paul Morrissey's trilogy—*Flesh, Trash, Heat*—that the hierarchy of
2:16 PM Nov 14th

332.　beauty, body, age, sex, gender, is dissolved. Joe is for everyone.
2:17 PM Nov 14th

333.　When the morally ambiguous sex-angel (Terence Stamp) in Pasolini's *Teorema* (1968) mysteriously arrives at the home of a bourgeois Milanese
4:21 PM Nov 14th

334.　family, the patriarch of the upper-class clan falls ill, causing the ideological life-support he provides to falter and recede. Later, when
4:22 PM Nov 14th

335.　the Father recovers, everything—him included—has changed. Through spiritual sex—the angel, who does not discriminate against sex or class—
4:23 PM Nov 14th

336.　sleeps with everyone. The angel himself does not desire or seek to possess; rather, he's merely a vessel of salvation and instigation, like
4:26 PM Nov 14th

337.　the erotically ameliorative specter (return of the repressed) in Toni Morrison's *Beloved*. After the angel sleeps with the son, the son,
4:30 PM Nov 14th

338.　transformed, tells the angel: "What made me like others has been destroyed…you've made me different. Taking me out of the natural order of
4:31 PM Nov 14th

339. things…And the awareness of losing you has become the awareness of being different," which is maybe the best line I've ever heard about the
4:32 PM Nov 14th

340. transformative possibilities of radical love (*Say Anything* is another example). *Teorema* also focuses on spectatorship because the film is
4:33 PM Nov 14th

341. ultimately concerned with the consequences of *how* we see: the framework, parameters, conditions, and limitations of our seeing (in many cases
4:35 PM Nov 14th

342. the frame falls around Terence Stamp's semi-erect dick — an object of ecstasy) and the way our seeing contributes to our *not* seeing, or being
4:36 PM Nov 14th

343. able to see, which makes me think of Bernini's 17th century sculpture, the Ecstasy of St. Teresa (alternatively, Saint Teresa in Ecstasy,
4:38 PM Nov 14th

344. or Transverberation of Saint Teresa), who experienced religious ecstasy after encountering an angel. In Teresa's written account, she
4:38 PM Nov 14th

345. describes the encounter: "I saw in his hand a long spear of gold, and at the iron's point there seemed to be a little fire. He appeared to me
4:39 PM Nov 14th

346. to be thrusting it at times into my heart, and to pierce my
 very entrails; when he drew it out, he seemed to draw
 them out also, and to
 4:40 PM Nov 14th

347. leave me all on fire with a great love of God. The pain was
 so great, that it made me moan; and yet so surpassing
 was the sweetness of this
 4:41 PM Nov 14th

348. excessive pain, that I could not wish to be rid of it. The
 soul is satisfied now with nothing less than God. The
 pain is not bodily, but
 4:42 PM Nov 14th

349. spiritual; though the body has its share in it." "The bodily
 seduction," writes architectural writer Robert Harbison,
 "is merely an opening
 4:42 PM Nov 14th

350. for another kind of experience and consciousness." It's
 telling then that when *Teorema's* angel is shown reading
 in the garden, and the
 4:43 PM Nov 14th

351. daughter asks him what he's reading, he quotes from the
 book, "He belonged to his own life and the turn of
 goodness," which I think is less
 4:44 PM Nov 14th

352. about afterlife, in the religious sense, and more about the
 spirituality of accountability. Every kind of account-
 ability. And the
 4:45 PM Nov 14th

353. way accountability can lead to the sacred. In an interview
about *Teorema*, Pasolini stated: "The characters live the
experience [of seducing
4:46 PM Nov 14th

354. the young man] but are not capable of understanding and
resolving it. This is the lesson of the movie—the
bourgeoisie have lost the sense of
4:47 PM Nov 14th

355. the sacred, and so they cannot solve their own lives in a
religious way." So last night, while watching Pasolini's
Teorema, I thought about
4:48 PM Nov 14th

356. how other people can only initiate the epiphanal process
for us. They cannot complete it or turn it into something
we can live. And this
4:49 PM Nov 14th

357. brings us back to the age-old divide between theory and
practice that pertains to everything and everyone.
4:50 PM Nov 14th

358. In the *Guardian*, one reader asks: "How can Courtney
Love, who has possibly written some of the most self-
aware lyrics, lack so much human
6:08 PM Nov 15th

359. understanding in day-to-day life?" I've been asking the
same question about people my whole life.
6:09 PM Nov 15th

360. "Now I know I have a heart...because it's breaking." The
 Tin Man
 10:13 PM Nov 16th

361. Doris Day has the kind of haughty blankness I thought
 for sure was thoroughly contemporary.
 10:34 PM Nov 17th

362. What's interesting about Hitchcock's *The Man Who Knew
 Too Much* (1956) is that it's actually a film about the
 everyday. Even in the midst of
 10:37 AM Nov 18th

363. the movie's assassination plot, the rest of the world—
 beyond the couple nucleus—doesn't stop or cease to
 exist, and the ins & outs of
 10:39 AM Nov 18th

364. reality aren't suspended because of one couple's personal
 crisis. Despite what's happening to Day and Stewart, and
 their son, they're still
 10:40 AM Nov 18th

365. shown paying for cab fare, hotel bills, packing, posing for
 the paparazzi (Day's character is a famous stage actress),
 and entertaining
 10:41 AM Nov 18th

366. guests. The quotidian prevails as a necessary part of life.
 In most Hollywood movies today, all that exists is the
 fantasy universe
 10:41 AM Nov 18th

367. of the plot. The world of the story. There is no greater world beyond the characters. Reality recedes. But Hitchcock—perhaps, because
10:44 AM Nov 18th

368. *The Man Who Knew Too Much* is a later film, and the allusions and lacunae of 40s noir have started to dissipate—blends the everyday into the
10:47 AM Nov 18th

369. screen horror, so that life literally *does* go on. The film also marks a transition from the hard-boiled pessimism of noir to the socially
10:48 AM Nov 18th

370. conscious and character-driven dramas of the 60s and 70s. *The Man Who Knew Too Much* has another great moment of transition. From Hitchcock's
10:54 AM Nov 18th

371. meta-director (director cameo) to meta-score (conductor Bernard Herrmann plays himself onscreen and can be seen on the poster when Doris Day
10:56 AM Nov 18th

372. exits the taxi at Albert Hall).
10:56 AM Nov 18th

373. Before there was James Frey's *A Million Little Pieces* (what The Smoking Gun called "Fiction Addiction and Frey calls "Fake Reality"), there
11:45 AM Nov 19th

374. was Clifford Irving, Elmyr de Hory, and Orson Welles' *F for Fake*—Orson Welles' film about Irving and de Hory. "Does it say
11:46 PM Nov 19th

375. something about this age of ours," asks Welles, "that [Irving] could only make it big by fakery?"
11:47 AM Nov 19th

376. "You're a liar and that's the truth." *Actor*, St. Vincent
3:14 PM Nov 20th

377. When it comes to celebrity, YouTube is interesting because you can literally watch actors being transformed (bastardized) by fame over time.
8:55 PM Nov 20th

378. Faces, bodies, personalities, accents, and speech patterns change dramatically. People stop telling the truth, become more articulate,
8:56 PM Nov 20th

379. rehearsed. Less and less open, trusting—natural. Everything becomes an act. Roles become permanent.
8:57 PM Nov 20th

380. "To be yourself in a world that is constantly trying to make you something else is the greatest accomplishment." Ralph Waldo Emerson
10:00 PM Nov 20th

381. Joe Dallesandro revolutionized the penis. Demystified it. Showed it in all its forms—soft and hard. Made it organic. No longer a weapon.
9:06 AM Nov 21st

382. "Consumption is being standardized." *THX 1138*
10:52 AM Nov 21st

383. In a quartet of short documentaries on NYC in the 1970s at the 92Y TriBeCa, one film in particular, *Crosby Street* (1975), moved me. In it,
12:59 PM Nov 21st

384. filmmaker Judy Saslow treats Soho's Crosby Street (which looks at the various economic, social, and aesthetic strata on the eponymous
12:59 PM Nov 21st

385. thoroughfare) as a microcosm of early gentrification in New York in the 70s—a period when New York City was often described as "dangerous"
1:00 PM Nov 21st

386. and "empty." But empty of what and of whom? What kind of people (ethos) constitute a population—a presence—or define the
1:01 PM Nov 21st

387. social and cultural value of a place? A time?
1:01 PM Nov 21st

388. In the astonishing documentary *Los Angeles Plays Itself*, Thom Anderson states: "Just because you love movies doesn't
1:42 PM Nov 21st

389. mean you take them seriously."
1:43 PM Nov 21st

390. "As thriller plots have lost their moorings in the real world of causes and effects, something valuable has been lost. When actions become
12:11 AM Nov 22nd

391. arbitrary, stories lose their power to help us make sense of the world and they become strictly formal patterns. Thus, many of us now turn
12:12 AM Nov 22nd

392. to documentaries for the emotional knowledge we once found in fiction films." Thom Anderson
12:12 AM Nov 22nd

393. The other day someone asked me if I thought John Cusack's Lloyd Dobler in *Say Anything* opened the door for actors like Joseph Gordon-Levitt,
1:00 AM Nov 22nd

394. and then, lo and behold, Levitt is on TV spoofing *Say Anything*'s famous boom box serenade on tonight's *Saturday Night Live*.
1:01 AM Nov 22nd

395. "The only paradise is paradise lost." Marcel Proust
1:38 AM Nov 22nd

396. More on the documentary *Crosby Street*: Shot in 16 mm
 film, *Crosby Street* opens at sunrise with an orchestral
 Hollywood score reminiscent of
 11:26 AM Nov 22nd

397. MGM musicals. The seemingly incongruent music signals
 New York City's transition from real place, with real
 people, to fiction, to fantasy,
 11:28 AM Nov 22nd

398. *Crosby Street* presents a version of New York that is so
 obsolete it literally looks like a period film. Like costume.
 Gentrification becomes
 11:29 AM Nov 22nd

399. its own genre, and people turn into commodifiable
 fictions because they no longer have value outside of
 stereotype.
 11:30 AM Nov 22nd

400. Because New York City in the 70s belongs to a glossary of
 a time, *Crosby Street* is especially interesting in 2009.
 While in 1975 it
 11:33 AM Nov 22nd

401. symbolized a neighborhood in transition, in 2009 it repre-
 sents an irreversible paradigmatic shift. A total shift in the
 way we live, think,
 11:34 AM Nov 22nd

402. and embody a city. *Crosby Street* is therefore in part about
 the way the more gentrified not just places, but people,
 and experiences (recall
 11:35 AM Nov 22nd

403. Steven Shaviro's comment on the gentrification of inner, psychological space in Todd Hayne's *Safe*, or what Douglas Ruskoff refers to in his
11:36 AM Nov 22nd

404. book *Life, Inc.*, as the corporatization of life itself) become, the more movies/TV/media become the primary spaces for
11:37 AM Nov 22nd

405. engagement, catharsis, and expression. But if that's truly the case does that mean that people have to be mediated characters — commodities — in
11:38 AM Nov 22nd

406. order to be real? That, as Roland Barthes pointed out, people have to be domesticated through representation? That they can only exist *as*
11:39 AM Nov 22nd

407. representation (see Reality TV)? Is "life," in the 21st Century, only for the people who get paid to act it? Personality is now synonymous
11:40 AM Nov 22nd

408. with brand. Being alive means being for sale.
11:41 AM Nov 22nd

409. "What are commodities but evidence of lost people?" Fanny Howe
11:26 PM Nov 23rd

410. Roman Polanksi's *Frantic* is such a bizarre film. It's really not a film. It's more like crisis (the kind Hollywood loves to aggrandize on
1:11 AM Nov 24th

411. screen) nulled by bureaucracy and regimentation. The way that corporate capitalism could give a fuck about one person's problems. Usually
1:12 AM Nov 24th

412. Hollywood depicts a world that bends to the will of one individual (hero). So it's kind of brilliant to take an action hero like Harrison Ford
1:13 AM Nov 24th

413. and make him powerless. Make him ineffectual. Ordinary. Slow. *Frantic* is actually the opposite of frantic. It is strangely languid.
1:14 AM Nov 24th

414. Thank God for Dustin Hoffman's nose. Thank God for anyone who keeps their real nose.
1:03 PM Nov 24th

415. Like Gregor Samsa in *The Metamorphosis*, David Lynch's John Merrick in *The Elephant Man* is modernity itself. The body as montage. Merrick's
4:13 PM Nov 24th

416. face and body is a mashup that represents the 19th century's fragmentation and industrialization. He is all parts. Pieces. The film is also a
4:14 PM Nov 24th

417. spoof of Eliza Doolitle and the 18th Century's sentimen-
 talism of the noble savage.
 4:20 PM Nov 24th

418. In the movie *Vanishing Point*, driving becomes so
 transcendent that at one point I think I heard the syllable
 Om somewhere in the film's score.
 2:39 AM Nov 25th

419. When I was seven, I took an evening painting class at The
 Children's Aid Society in NYC's Greenwich Village.
 While we painted, my art teacher,
 1:27 PM Nov 25th

420. Linda, would act out scenes from Brian De Palma's *Carrie*
 and *Dressed to Kill*, and all the kids would listen, spell-
 bound and lulled, as though
 3:35 PM Nov 25th

421. Linda was telling us a bedtime story.
 3:39 PM Nov 25th

422. *Yves St. Laurent: His Life and Times* has YSL looking at a
 screen that shows his life, which spawns a biography; a
 life made from images; images
 1:19 AM Nov 26th

423. YSL has to see in order for them to feel real, which is what
 life is like for most people these days. First YSL looks at
 the images of his
 1:21 AM Nov 26th

424. life onscreen, which we watch him do, and then we see
what he sees.
1:22 AM Nov 26th

425. "It seemed real. It seemed like us." *Raising Arizona*
5:59 PM Nov 26th

426. Watching *Raising Arizona*. Do I think Nicholas Cage is so
pretty because I'm shocked by what age can sometimes
take away from people?
11:53 AM Nov 27th

427. In *Sleepless in Seattle*, Meg Ryan and Tom Hanks have the
same nose. Is semblance why they love each other?
10:48 AM Nov 28th

428. The best moment in John Sayles' *Return of the Secaucus 7* is
when he has men instead of women play the bathing
beauties at the swimming cove.
11:30 AM Nov 28th

429. While the camera basks on the men's naked bodies (Sayles
is one of the naked sea sirens), and shows them diving
into the water
11:32 AM Nov 28th

430. over and over, then posing from behind like Greco-Roman
sculptures, the women sit talking and looking, fully clad.
11:32 AM Nov 28th

431. I know I should watch the other three Antoine Doinel
films before I watch the fourth installation, *Bed and Board*.
But after *The 400 Blows*,
12:01 PM Nov 28th

432. I don't think I can.
 12:02 PM Nov 28th

433. At the very end of *F for Fake*, Orson Welles offers a wrap-
 up; a flashback on trickery (the mystery of mystery—all
 its intersections,
 11:49 PM Nov 28th

434. diversions, and variations), and the music suddenly
 seems awfully familiar. And it occurs to me that *The Usual
 Suspects*, which supposedly
 11:50 PM Nov 28th

435. mimics the structure of *Citizen Kane*, seems to owe much
 more to *F for Fake*. Welles, the grandfather of noir after all,
 even says, "Hoya's
 11:51 PM Nov 28th

436. grandfather has no comment because he never even
 existed," which is essentially the same thing as Verbal
 saying, "The greatest trick the
 11:53 PM Nov 28th

437. Devil ever pulled was convincing the world he didn't
 exist."
 11:54 Nov 28th

438. If Angelina Jolie "isn't Republican," as *Us Magazine*
 informs, then why does she say things like, "Obama is
 really a socialist in disguise?"
 11:58 PM Nov 28th

439. "If we can appreciate documentaries for their dramatic qualities, perhaps we can appreciate fiction films for their documentary
 11:37 AM Nov 29th

440. revelations." Thom Anderson, *Los Angeles Plays Itself*
 11:37 AM Nov 29th

441. For the past decade, John Cusack's career has been the equivalent of the earth's shifting crust in *2012*. Disastrous.
 10:06 PM Nov 29th

442. Was Guy Maddin thinking of Tarkovsky's *The Mirror* when he made *My Winnipeg*? Nation as personal biography and personal biography as nation.
 9:51 AM Nov 30th

443. *The Ice Storm* is like boring wallpaper. It wants to say something, but should be torn off instead.
 12:26 PM Nov 30th

444. Chris Rock has partially redeemed himself by making the documentary *Good Hair*, which is about black women's relationship to their hair. At
 5:48 PM December 1st

445. one point, on *Oprah*, Rock asked the dyed blonde comedian, Ali Wentworth, why she thought looking like everyone else would make her beauty
 5:49 PM Dec 1st

446. "stand out?" Good question. But it's the standard of
 thought when it comes to beauty. After that, the camera
 panned across a sea of middle-
 5:50 PM Dec 1st

447. class white women with bleached blonde hair in the
 audience. I think Rock might have a more radical
 message than the one Oprah took
 5:50 PM Dec 1st

448. away and advocated on her show. Like: everything, even
 hair weaves, has a source, comes from somewhere and
 someone. But more importantly, if
 5:52 PM Dec 1st

449. you tell everyone to think about and do something differ-
 ently—to see the injustice in something—then you can't
 also tell them to *continue*
 5:54 PM Dec 1st

450. doing what they're doing, since that's what caused the
 problem in the first place. In an interview in *Bitch
 Magazine* a few years ago,
 5:58 PM Dec 1st

451. feminist theorist Susan Bordo challenged the idea of
 where "me," of "doing something just for me" (from
 staying home and raising
 5:59 PM Dec 1st

452. kids to getting plastic surgery), comes from. "Me" does
 not exist in a vacuum. It's a cultural construct. In the
 mainstream, activism really
 6:01 PM Dec 1st

453. has come to mean doing nothing differently. In other
 words, all talk and no action.
 6:01 PM Dec 1st

454. "The line between fiction and reality, friend and marketer,
 community and shopping center, has gotten blurred."
 Douglas Rushkoff, *Life, Inc.*
 7:08 PM Dec 2nd

455. "Ice age coming/Ice age coming/Let me hear both
 sides/Let me hear both sides/This is really happening."
 Radiohead
 9:01 PM Dec 2nd

456. According to consumer culture, when it comes to most
 issues, nothing different has to happen in order for
 something different to happen, and
 9:34 PM Dec 2nd

457. I think this is ultimately what *2012* is saying too. That the
 whole world could literally end, but structurally and
 ideologically, everything
 9:40 PM Dec 2nd

458. would remain exactly the same, which is why the film's
 ending is so reassuring. In *2012*, everything is gone, apart
 from the corruption and elite
 9:41 PM Dec 2nd

459. class (old social order) that will reproduce, both biologi-
 cally and systemically, the very things that an apocalypse
 could potentially
 9:43 PM Dec 2nd

460. eradicate. Instead, director Roland Emmerich helps the world's elite escape the destruction in aquatic spaceships, while everything and
9:46 PM Dec 2nd

461. everyone else perishes. Or maybe that's not true at all. Maybe things can only really ever change if people — not "the world" — changes.
9:55 PM Dec 2nd

462. Jack Nicholson had a good nose. I think that's why Polanski cut it off in *Chinatown*.
11:02 PM Dec 3rd

463. In 2002, I went to see *The Secretary* at the Angelika Film Theater in New York, but the screening was delayed for over an hour due to some
1:03 PM Dec 4th

464. technical malfunction. I waited for the problem to be fixed while sitting on the floor, along with everyone else. This everyone else
1:06 PM Dec 4th

465. included Monica Lewinsky and her two girlfriends. You can't make this stuff up. I mean you can, but I didn't.
1:11 PM Dec 4th

466. Since somewhere around *Lethal Weapon*, Mel Gibson has managed to do a crucifixion scene in every one of his movies either literally,
10:02 PM Dec 4th

467. figuratively, or, in the case of his new film *Edge of Darkness*—where he barks, "you better decide whether you're hanging on the
10:03 PM Dec 4th

468. cross or banging in the nails"—verbally.
10:03 PM Dec 4th

469. Given that the reverence mother and daughter have for father/husband in the original *Cape Fear* has all but deteriorated by the time we get
11:18 PM Dec 5th

470. to the remake, it's as though Scorsese's version is simply a moral duel between who is worse—the father or Max Cady. Between
11:19 PM Dec 5th

471. the symbolic Father then and the symbolic Father now. And because Cady proves to be worse, the father wins and gets to be the
11:20 PM Dec 5th

472. father again. In the remake, it's the outside that matters. In the original, it's the inside. The first *Cape Fear* is about the way this
11:21 PM Dec 5th

473. outside (Cady) makes its way in. But Scorsese knows that what was once outside is now (and always has been) inside. That the family unit is
11:22 PM Dec 5th

474. no longer intact, therefore keeping it (Cady) "out" is futile. The movie is merely a perfunctory, symbolic gesture of keeping what is in, out.
11:23 PM Dec 5th

475. "Is Dad dead again already?" *Brodre*
12:47 AM Dec 6th

476. Musicals are about expressing yourself in a world where you can't express yourself.
3:11 PM Dec 6th

477. Has Sean Penn always played a half-witted hysteric? It seems that way when you look at his filmography: from Spicoli to *I Am Sam* to *Milk*.
7:18 PM Dec 7th

478. I'm beginning to realize that when it comes to reviewing well-known people's work, critics are often willing to invent content that
11:55 AM Dec 8th

479. sometimes isn't even there. But when it comes to work by un-established people, critics routinely, even pathologically, neglect the content
11:57 AM Dec 8th

480. that is there.
11:57 AM Dec 8th

481. In America, when you attack the culture industry, you are called cynical. But it should be the other way around.
8:21 PM Dec 9th

482. "I wonder if there's some place in this world where people go to get better." *Red Desert*
11:14 PM Dec 9th

483. Why does Steven Soderbergh's *The Girlfriend Experience* reek of the same cheesy, made-for-TV maladroitness as Ed Burns' *She's The One*?
9:41 PM Dec 10th

484. If, as *The Girlfriend Experience* displays, you can control and summon behavior in order to become the girlfriend or boyfriend experience —
3:13 PM Dec 10th

485. feigning interest, care, understanding, intimacy, in a way that both the escorts and clients believe to be at least partially genuine — then
3:14 PM Dec 10th

486. why can't people conjure these qualities in *real* relationships? Is it because rather than master the art of loving, we've mastered the art
3:15 PM Dec 10th

487. of capitalism? In other words, does the context have to be artificial and does money have to be the driving impetus? What if it were love?
3:18 PM Dec 10th

488. And if money is love, and love is money, then have we finally succeeded in creating a culture (the motto of corporate capitalism) where
3:20 PM Dec 10th

489. money, and only money now, truly does make the world go round? *The Girlfriend Experience* sees the world—the heart—as finance; as market. In
3:21 PM Dec 10th

490. response to A.O. Scott's *NY Times* review of *The Girlfriend Experience,* one reader, "Ben," puts it best: "There seems to be a presumption by the makers
3:23 PM Dec 10th

491. that the premise of this film is somehow subversive and important. It's not if they have nothing to say beyond pretension and cliché."
3:24 PM Dec 10th

492. "Oprah has made it impossible for me to have a close relationship with anyone besides Oprah." *Adam & Steve*
11:17 PM Dec 11th

493. "Even if you knew what to do, you wouldn't know what to do." *The Road*
1:20 PM Dec 11th

494. *The Road*: bills and jewels covered in ash, Viggo Mortensen's incredible, teary-eyed face, a son who practices daily acts of kindness and
1:40 PM Dec 11th

495. compassion, the father-son love story, and most radical of all, the balance between connection and conflict; despair and hope.
1:41 PM Dec 11th

496. I've always disliked Noah Baumbach's reactionary, mean-spirited films, and now that I know he also wrote *Kicking and Screaming* and *Mr.*
12:01 PM Dec 12th

497. *Jealousy*, it's official, I can't stand his writing or his movies. Having the icy, irascible, and uptight in every sense of the word (he's the same
12:01 PM Dec 12th

498. offscreen), Ben Stiller replace the lovely Mark Ruffalo as the lead in Baumbach's new movie, *Greenberg*, is case in point.
12:03 PM Dec 12th

499. I finally watched *Broadway Danny Rose*, in which Mia Farrow is fantastic, today. The most hysterical scene has Woody Allen and Mia Farrow—who
4:42 PM Dec 12th

500. are tied together by Italian mobsters and have to "wriggle" their way out of the rope—lying bound and on top of each other. Allen, whose face
4:44 PM Dec 12th

501. is literally on Farrow's, bellyaches. The comic beauty lies in the juxtaposition between sonority and proximity.
4:46 PM Dec 12th

502. While doing the interview circuit for *Brothers*, Natalie Portman routinely denied that the film is about anything other than "family."
9:59 AM Dec 13th

503. "If you hate yourself, you hate your work." *Broadway Danny Rose*
10:27 AM Dec 13th

504. On my way back from Pennsylvania today, I mistakenly read the truck sign "Vehicle makes frequent stops" for "Violence makes frequent stops."
7:58 PM Dec 14th

505. While I was not actually old enough to watch the films that came out in the 70s, I feel like the DNA of the decade is in my
11:55 AM Dec 15th

506. blood. I have doubt and I have hope.
12:01 PM Dec 15th

507. While critic Armond White's film reviews may be problematic and inconsistent, bringing up issues of race, class, and gender when
4:48 PM Dec 15th

508. analyzing cultural production is not. I think some of the responses to his reviews are absolutely disturbing and bludgeoning (often
4:50 PM Dec 15th

509. resembling a verbal lynching). I don't think a man should be demonized or called an idiot and a racist—especially by white people—for
4:51 PM Dec 15th

510. pointing out the white supremacy that's still rampant in our culture. I'm certainly not interested in the apolitical and empty critiques that
4:52 PM Dec 15th

511. dominate most film criticism today.
4:53 PM Dec 15th

512. "What I do is art. I can make people interested in you when there's nothing interesting about you. We're corrupting more and more
5:57 PM Dec 15th

513. people," Jill Ishkanian, *US Weekly* editor. In her memoir *What Falls Away*, Mia Farrow writes that during the Sun-Ye scandal, Woody Allen, who
5:58 PM Dec 15th

514. also makes art, told her, "It doesn't matter what's true. All that matters is what's believed;" And Joseph E. Levine, the founder of
5:59 PM Dec 15th

515. Embassy Pictures, remarked, "You can fool all of the people all of the time if the advertising is right."
5:59 PM Dec 15th

516. After watching the documentary *Food, Inc.* this weekend, and asking myself what the major difference between America and Europe is in terms
7:12 PM Dec 15th

517. of consumer ethics and industrial production, I find part
 of the answer in another documentary, *America the
 Beautiful*, where toxicologist
 7:13 PM Dec 15th

518. Urvashi Rangan informs: "Since the 67 years of the food
 and drug administration being established, they have
 only banned six ingredients
 7:14 PM Dec 15th

519. in cosmetic products, whereas the European union has
 banned 450 chemical ingredients in cosmetics. In Europe
 you really need to prove that
 7:14 PM Dec 15th

520. something is safe before you allow it to be used."
 7:15 PM Dec 15th

521. Rhianna's new partially nude photo spread in *GQ* is not
 about "being in control" or, as she puts it, "finally getting
 to let go." It's about
 5:00 PM Dec 16th

522. reestablishing herself as a commodity and sex object after
 Chris Brown. "I wanted people to move on with me cause
 the last big thing they
 5:01 PM Dec 16th

523. know about me is That Night," says Rhianna. "I don't
 want that to be what people define me as."
 5:04 PM Dec 16th

524. In a performance culture like America, what happens if you're not seen performing? Are you as good as dead?
8:19 PM Dec 16th

525. "Because Neytiri [of *Avatar*] was designed by an all-male design team she is smoking hot...We spent 6 months alone working on her butt." James Cameron
12:33 AM Dec 17th

526. Daniel Day Lewis' performance in *Nine* looks embarrassing. *Nine* (the new *8 ½*) looks embarrassing. And if I have to hear the entire female
1:23 AM Dec 17th

527. cast refer to Lewis as a "genius" one more time, I'm going to throw up.
1:24 AM Dec 17th

528. There are always quotation marks around every role that Daniel Day Lewis does. His relationship to acting, and his reputation as an actor,
11:41 AM Dec 17th

529. is so histrionic and naive. He's always acting as if acting were real.
11:41 AM Dec 17th

530. "Fear was hidden in all corners of the town. Who was still healthy? Who was already sick?" *Nosferatu* (1922)
4:06 PM Dec 17th

531. In Hollywood, actresses often go through a period of thinning out, or even anorexia. They shrink (then deny their diminishment) as a way to
4:24 PM Dec 17th

532. re-establish boundaries that have been eroded by fame. Since so many actresses are ground down by the process of being intensely scrutinized
4:35 PM Dec 17th

533. and consumed, they purposely make less of themselves to "eat." Thus, the more they appear, the more they *disappear.* An obesity of image-
4:36 PM Dec 17th

534. consumption results in a diet of body (producers tell actresses they look fat in dailies. On the set of *An Officer and a Gentlemen,* the
4:37 PM Dec 17th

535. legendary film producer Don Simpson famously told actress Debra Winger to take diet pills to eliminate her "bloat"). In the novel *What*
4:38 PM Dec 17th

536. *I Loved,* Siri Hustvedt writes, "Violet was on a mission to uncover the afflictions she called 'inverted hysterias.' Nowadays, girls *make*
4:39 PM Dec 17th

537. boundaries. Hysterics wanted to explode them. Anorexics build them out.'" Anorexics perceive the outside as a threat and use their own body
4:40 PM Dec 17th

538. to block it. For a famous actress, the outside becomes in. A net, the actress imbibes the desires of everyone around her; all the people who
4:41 PM Dec 17th

539. look at her and watch her and dissect her. Being onscreen creates an enormous opening, so the actress must cross the line when it comes to
4:42 PM Dec 17th

540. her own body. "Those girls," writes Hustvedt, "have overmixed...they find it hard to separate the needs and desires of other people from their
4:43 PM Dec 17th

541. own...They want to close up all their openings so nothing and nobody can get in. But mixing is the way of the world. The world passes through
4:44 PM Dec 17th

542. us—food, books, pictures, other people..."
4:45 PM Dec 17th

543. "All her inside is out." Udo Kier in *Flesh for Frankenstein*
6:49 PM Dec 17th

544. In *Twilight Zone*, feminist theorist Susan Bordo writes, "Eating disorders are 'deeper than just obedience to images. Cultural images
8:38 PM Dec 17th

545. *themselves are* deep.'" Or, as horror filmmaker, Tobe
 Hooper puts it in *The American Nightmare*, "Images really
 blow into the nightmare."
 8:39 PM Dec 17th

546. "As we investigate the story of Karen Carpenter's life and
 death we are presented with an extremely graphic picture
 of the internal
 12:41 PM Dec 18th

547. experience of contemporary femininity. We will see how
 Karen's visibility as a popular singer only intensified
 certain difficulties many
 12:42 PM Dec 18th

548. women experience in relation to their bodies." Todd
 Haynes' *Superstar: The Karen Carpenter Story*
 12:42 PM Dec 18th

549. While most people struggle with a depression of the self,
 I think what I have, or have always had, is a feeling of
 Weltschmerz (world
 7:54 PM Dec 19th

550. sadness or pain), or "depression caused by comparison of
 the actual state of the world with an ideal state." In
 Stagestruck, Sarah Schulman
 7:54 PM Dec 19th

551. refers to Weltschmerz as cultural grief.
 7:55 PM Dec 19th

552. "'I can't make this movie," [Guido] sings. Substitute "watch"
 for "make" and provide your own music.'" A.O. Scott on *Nine*
 11:54 AM Dec 20th

553. The writer (as character) is important to Tarkovsky the
 way that the actor (as character) is important to Bergman.
 They are archetypes and
 11:58 AM Dec 20th

554. categories of existence.
 11:59 AM Dec 20th

555. De Palma's *Femme Fatale* is made up of cinema history and
 De Palma history. Rebecca Romijn is a noir composite and
 a De Palma composite.
 3:56 PM Dec 20th

556. Is beauty when you can't get used to what someone looks
 like?
 4:11 PM Dec 20th

557. Robin Wood, a film critic who's influenced me
 profoundly, has died. RIP.
 11:36 PM Dec 20th

558. "From first scene to last, [Richard Linklater's] *Before
 Sunrise* systematically and rigorously resists encouraging
 identification with one
 1:50 PM Dec 21st

559. character above or against the other (it's difficult to think
 of any other film that achieves quite this feat). Do men
 automatically
 1:51 PM Dec 21st

560.　identify with the male, women with the female? I doubt it, although our gender may of course entail a certain bias, which the film goes
1:53 PM Dec 21st

561.　out of its way to undermine." Robin Wood on *Before Sunrise*
1:53 PM Dec 21st

562.　"Images begin to well up like confessions." *La Jetée*
8:12 PM Dec 21st

563.　"What if a character could win his autonomy, his independence, not only by creating loopholes in time, but loopholes in films—cracks,
8:39 PM Dec 21st

564.　bridges, pathways?...For the character in *La Jetée*, the goal is to find an image from a film that marked him in the past—Madeleine in *Vertigo*
8:40 PM Dec 21st

565.　—and attempt to perhaps join her...Our man reviews all the static images from the films that crowd his memory but aren't really what he's
8:40 PM Dec 21st

566.　after. He's trying to find *Vertigo*...Then, 12 minutes into the film, the reunion. The young woman the character will fall in love with first
8:41 PM Dec 21st

567. appears. The same framing, the same profile, the same hairstyle, the same bewitching charm of Madeleine's first appearance in *Vertigo*.
8:41 PM Dec 21st

568. The character has found the door into Hitchcock's film...Once inside the film of *Vertigo*, our character takes the place of James Stewart.
8:42 PM Dec 21st

569. He lives scenes already experienced by another. By reading between the lines *La Jetée* is also the story of a filmmaker, Chris Marker, marked
8:42 PM Dec 21st

570. forever by a character in a film he wants to find and maybe even meet. Marker dreams here of a cinema so magically powerful that it can
8:43 PM Dec 21st

571. induce vertigo. After all, if an image has the power to make us fall in love with it, if an image can work its way into our daily life,
8:43 PM Dec 21st

572. couldn't we do the same and take a trip in the other direction?...Chris Marker saw *Vertigo* nineteen times, as we learn in *Sans Soleil*.
8:44 PM Dec 21st

573. Nineteen times he was pulled into *Vertigo*'s spiral." *Court-Circuit (le magazine)*
8:44 PM Dec 21st

574. I'm convinced that at the end of *E.T.*, just before E.T. gets on the spaceship to go home, *My Fair Lady's* "I Could Have Danced All Night" makes a
4:14 PM Dec 21st

575. cameo appearance in John Williams' score. Does that make E.T. Eliza Doolitle and Elliott the Pygmalion Henry Higgins?
4:14 PM Dec 21st

576. In *Funny Girl*, Barbra Streisand began her life-long, onscreen pursuit of the WASP man. There was Ryan O'Neal in *What's Up, Doc?*,
11:06 PM Dec 22nd

577. Robert Redford in *The Way We Were*, Nick Nolte in *The Prince of Tides*, Jeff Bridges in *The Mirror Has Two Faces*. In *Meet the Fockers* Streisand
11:07 PM Dec 22nd

578. plays the bohemian Jewish mother of Ben Stiller, who rebels against his mother's openness and non-tradition-alism by longing for the approval
11:09 PM Dec 22nd

579. of Robert De Niro's repressed WASP patriarch. And yesterday, in a TV interview where Streisand gushed over how "disgustingly perfect" her
11:10 PM Dec 22nd

580. husband James Brolin is, in a way that, according to Streisand, she could "never" be ("he looks like that while he's sleeping"), I realized
11:11 PM Dec 22nd

581. she's been chasing (and finally landed) the WASP man
 offscreen too.
 11:12 PM Dec 22nd

582. If, as Ralph Nader said, the car is a psycho-sexual dream
 boat, with its very own built-in movie screen, then the car
 in *Vertigo* (a
 12:32 AM Dec 23rd

583. symbol of the male power drive) is the way into the spiral
 of obsession (Scottie's fantasy regression). The morning
 after Madeleine jumps into
 12:33 AM Dec 23rd

584. the SF Bay, James Stewart is literally driving down hill in
 what turns out to be a disorienting loop that doesn't make
 sense spatially. This is
 12:34 AM Dec 23rd

585. when space stops being real. When it becomes desire. In
 "Hysteric," the Yeah Yeah Yeahs sing: "No longer, no
 longer/These strange steps
 12:35 AM Dec 23rd

586. take us back."
 12:36 AM Dec 23rd

587. Is it possible that Krzysztof Kiewslowki's red profile of
 Valentine in *Red* came from Hitchcock's red profile of
 Madeleine in *Vertigo*?
 12:48 AM Dec 24th

588. "I don't care anymore about me." Madeleine/Judy in *Vertigo*
2:03 AM Dec 24th

589. Madeleine (*Vertigo*) rhymes with Valentine (*Red*).
1:32 PM Dec 24th

590. Watched the drawn-out *Funny People* last night (another pathologically scatological Judd Apatow production), which really does give new
1:14 PM Dec 25th

591. meaning to what can only be called phallocentrism: "The privileging of the masculine (the phallus) in understanding meaning or social
1:15 PM Dec 25th

592. relation." In *Funny People*, and *Superbad* before it, there's no heart or brain left, there's only dick. Dick instead of Body. Dick as élan.
1:16 PM Dec 25th

593. That's what all of Seth's compulsive dick drawings testify to at the end of *Superbad*. Dick as divine logos. And the obsession with fixed
1:17 PM Dec 25th

594. classifications is the menstrual blood (the monstrous feminine) that ends up on Seth's thigh at the party. That seeps through her clothes and
1:18 PM Dec 25th

595. into his. Onto him. The unclassified fluid versus the fixed structure.
1:21 PM Dec 25th

596. "All women have a built-in grain of indestructibility and men's task has always been to make them realize it as late as possible...How long
3:17 PM Dec 26th

597. will it take to forget the secret?" *San Soleil*
3:18 PM Dec 26th

598. Not sure how I feel about *Julia*, except that it's definitely a comprehensive rendering of and meditation on sobriety. Life is what causes
11:50 AM Dec 27th

599. Julia to start drinking and life—not AA—is what makes her stop.
11:50 AM Dec 27th

600. Film critic Ella Taylor argues that *A Serious Man* "is a work of Jewish self-loathing." "The fun of the story for us," state the Coen brothers,
2:05 PM Dec 27th

601. "was inventing new ways to torture Larry." But before there was Larry Gopnik in *A Serious Man*, there was Aaron Altman in *Broadcast News*.
2:06 PM Dec 27th

602. James Spader says he doesn't remember making *Pretty in Pink*. There is clearly a huge difference between what a role means to an actor and what
6:38 PM Dec 27th

603. a role means to a viewer.
6:39 PM Dec 27th

604. Unlike *Grace is Gone* and the American version of *Brothers*, *The Visitor* is a remarkable film about what systems do to people. In the movie,
5:31 PM Dec 28th

605. everyone is slowly broken up by America's post 9/11 system: Tarek loses his life, Zainab, his girlfriend, loses Tarek, Mouna, Tarek's
5:32 PM Dec 28th

606. mother, loses her son, after losing her political journalist husband to the Syrian prison system, and Mouna and Walter lose the possibility
5:32 PM Dec 28th

607. for a life of real love together.
5:33 PM Dec 28th

608. Watched Norman Jewison's *...And Justice for All* late last night and was kind of blown away by Pacino's range and vulnerability. It's no secret
11:15 AM Dec 30th

609. that the 70s were Pacino's decade, and though I like him in *The Godfather* and *Serpico* (and most of all, *The Panic in Needle Park*), I think
11:16 AM Dec 30th

610. what he does in *And Justice for All* actually better. Then, an hour into the movie, it occurred to me that Pacino never got the kitschy
11:17 AM Dec 30th

611. theatrics of Tony Montana in *Scarface* (1983) out of his system. A difference of only a couple of years in terms of acting, *And Justice for*
11:20 AM Dec 30th

612. *All* and *Scarface* are worlds apart. Part of me thinks this is because in the 70s Pacino worked hard. Was vulnerable, kinetic, pliable. But
11:22 AM Dec 30th

613. after *Scarface,* he became an overpaid star; an icon, like *The Godfather* and *Scarface* t-shirts that men all over the world wear. He got smug—
11:23 AM Dec 30th

614. established. His talent became commercial. His acting became shtick. His cadences, decibels, and gestures stock—costume.
11:24 AM Dec 30th

615. You can see his arrogance and bravado bloat the screen in *Sea of Love, Scent of a Woman, The Devil's Advocate, Any Given Sunday.* It
11:28 AM Dec 30th

616. manifests as sloppy exteriority. Volume. Vibrato (in Pacino's case, this famously means yelling) to evoke emotion and power. Even his eyes
11:29 AM Dec 30th

617. changed. Pacino used to have fantastic eyes.
11:29 AM Dec 30th

618. In Catherine Breillat's *Sex is Comedy*, the director, Jeanne, tells The Actor, "You waste your charm. There's none left for the camera." But
12:03 PM Dec 30th

619. actually the reverse is true. As we become a camera society, actors and non-actors alike, become increasingly dull and lifeless offscreen.
12:05 PM Dec 30th

620. "People want to talk to cameras." Jennifer Fox, documentarian
4:16 PM Dec 30th

621. If Bernard Herrmann's scores were about obsessive limbo and repetitive structures, is Philip Glass the avantgarde version of Herrmann?
8:17 PM Dec 30th

622. In *Shattered Glass*, Hayden Christensen, whose Stephen Glass reminds me of Verbal Kint from *The Usual Suspects*, plays the perfect
1:28 PM Dec 30th

623. sociopath. In both films, the story of self is a self-edited fiction.
1:29 PM Dec 30th

624. "Reality is a reconstruction of our ideas of what reality is, as much as the social is a reenactment of what we think the social ought to be
3:24 PM Dec 30th

625. like." Martijn Van Berkum
 3:25 PM Dec 30th

626. When it comes to Robert De Niro's face, it ended up
 (*Everything's Fine*) where it started (*The Wedding Party*). In
 the middle (*Mean Streets*
 3:33 PM January 1st

627. and *Taxi Driver*), there was beauty.
 3:33 PM Jan 1st

628. After watching *Wal-Mart: The High Cost of Low Price*
 (which is a kind of horror movie about American
 capitalism), I am basically speechless,
 11:04 AM Jan 2nd

629. and then later, in *Inside Deep Throat*, Gore Vidal says,
 "When a country lies about everything, there is no
 reality." Is this why we have
 11:05 AM Jan 2nd

630. Reality TV? To replace reality? In *Pop Art: Object and Image*
 Christopher Finch writes, "Illusion verges on reality and
 beguiles us into
 11:05 AM Jan 2nd

631. accepting the language of reality."
 11:06 AM Jan 2nd

632. Re-watching *Barry Lyndon*. It's hard to reconcile the puffy
 out-of-work Ryan O'Neal with the 70s screen star, who
 was actually, if you
 10:29 AM Jan 3rd

633. compare *What's Up, Doc?* with *Barry Lyndon,* a pretty
 good actor in a thermostatic kind of way. O'Neal's acting,
 poised somewhere between
 10:30 AM Jan 3rd

634. silent film star (*Barry Lyndon*) and taciturn male noir (*The
 Driver*), is mostly about temperature. Raising it and
 lowering it. Freezing or
 10:30 AM Jan 3rd

635. heating up a room. No one emotes quite like he did. On
 TV this summer, O'Neal was ruddy, with doll cheeks and
 a belly. He always looks like he's
 10:31 AM Jan 3rd

636. too warm or about to cry. He's lost the ability to control
 his temperature because the woman he loved was dying.
 10:31 AM Jan 3rd

637. "In the movies people always have the ability to say what
 they mean." Ryan Gosling
 10:13 PM Jan 3rd

638. There are many great things about John Cassavetes'
 movies, and some of his films have meant the world to
 me (*Love Streams, Opening Night,*
 12:00 PM Jan 4th

639. *Gloria*), but they're also kind of hysterical and pushy and
 autistic and exhausting, especially *Husbands* and *Minnie
 and Moskowitz.*
 12:04 PM Jan 4th

640. If in most movies people have the ability to say what they mean; that there's an idealized access to language, then John Cassavetes' films,
12:51 PM Jan 4th

641. which are largely *about* language—how we talk, how we say what we don't mean much of the time; how we say *too* much—are just the opposite.
12:52 PM Jan 4th

642. Like in *Jaws*, in John Cassavetes' *Husbands*, three drunk men sing, "Show me the way to go home" in the dark. Both films employ the male
6:41 PM Jan 4th

643. triptych. A three-way mirror even appears in *Husband's* London hotel scenes, turning the men into six or pairs of two. In *Jaws*, the shark's maw
6:45 PM Jan 4th

644. is also a triangle. So is each individual tooth. Both films recall film critic Andrew Britton's line, "The dream was very much male."
6:52 PM Jan 4th

645. Rebecca Brown's "Do we do dirt now in order to tell it?" echoes Oscar Wilde's "Things are because we see them."
10:45 PM Jan 5th

646. On the commentary track for *The Grifters*, Donald Westlake, the movie's screenwriter, recalls meeting a young woman at a party a year after
6:47 PM Jan 6th

647. *The Grifters* was released. According to her, John Cusack's conman, Roy Dillion, was still alive. "But that's impossible," Westlake responded,
6:48 PM Jan 6th

648. stunned. "Roy gets killed." Yet despite the bloody unequivocality of his death, the woman continued to insist that Roy Dillion was still
6:52 PM Jan 6th

649. alive. "The very last thing we see, as Lilly drives off with Roy's money," the woman told Westlake, "is Roy running across the street."
6:53 PM Jan 6th

650. In Nicolas Roeg's *Walkabout*, sound is the dawn of time and the end of time. In *2001: A Space Odyssey*, it's the bone thrown into the air.
8:19 PM Jan 6th

651. In the making of *The Limits of Control* feauturette, Jim Jarmusch says there are a limited amount of stories to tell, but an unlimited
1:38 PM Jan 7th

652. variety of ways to tell them, and that's what *The Limits of Control* is about: The same story told scene after scene, the same thing
1:38 PM Jan 7th

653. happening, over and over, day after day, but each time reconfigured in some new way, by some new thing. "In the near future," says
1:39 PM Jan 7th

654. Molecules, the lady on the train, "worn out things will be made new by reconfiguring the molecules." And this, Jarmusch is saying, is also
1:41 PM Jan 7th

655. the future of stories. In a sense, each matchbox exchange then is the same story, or the story itself, but reconfigured by assigning
1:43 PM Jan 7th

656. different people to perform the action, so that the exchange of matchboxes is not about the exchange of information or plot direction, but
1:44 PM Jan 7th

657. rather, a reconfiguration of the same narrative molecules. And, as is the case in every Jarmusch film, the same words or phrases are also
1:45 PM Jan 7th

658. reconfigured and recontextualized, so that "He who thinks he's bigger than the rest, must go to the cemetery. There he will see what the
1:47 PM Jan 7th

659. world really is...," which is stated at the beginning of the film at the airport, both in French and in English (also a reconfiguration),
1:48 PM Jan 7th

660. is later sung in Spanish by a Flamenco singer during a dance rehearsal. Similarly, "Everything changes by the color of the glass you see it
1:51 PM Jan 7th

661. through" is also a play on the theme of perception. To
 show this, everything is repeated in order to demonstrate
 that nothing is
 1:52 PM Jan 7th

662. ever the same thing. I also like the way Isaach De Bankole
 only looks at one painting a day at the Museo Nacional in
 Madrid. But
 1:58 PM Jan 7th

663. Jarmusch fetishizes his actors too much. Not necessarily
 the way they look or dress, or the music that decorates
 them in a scene, though
 1:59 PM Jan 7th

664. there is that. But through their actual being in his films
 (think of *Broken Flowers*, which feels like a series of gratu-
 itous cameos). The
 2:00 PM Jan 7th

665. naked Paz de la Huerta, who is unbearable (tacky) to
 watch, is a perfect example of Jarmusch's fetishism. De La
 Huerta is Jarmusch trying to
 2:01 PM Jan 7th

666. throw the audience a bone for sitting through a purely
 metaphysical exercise. Isaach De Bankole is literally the
 movie's mis-en-scène.
 2:03 PM Jan 7th

667. One of the most interesting scenes belongs to a powdery-
 white Tilda Swinton, who is the specter of cinema; who
 comments both on film —
 2:04 PM January 7th

668. the world as film or film as world—and the film itself.
 2:05 PM Jan 7th

669. "Haneke's interested in the idea of living through
 television, the window of the television, instead of a
 window to the world. Our view of
 4:38 PM Jan7[th]

670. the world is truncated. It's those two realities, those two
 perspectives—what we live and what we see—that
 interest him." Juliette Binoche
 4:39 PM Jan 7th

671. Like people, a lot of movies are not who they say they are.
 8:43 PM Jan 7th

672. "Tell me what you're so upset about. I'll tell you whether
 or not it's real." *The King of Marvin Gardens*
 9:34 PM Jan 7th

673. "By using Helvetica, corporations can come off seeming
 more accessible, transparent, and accountable. Now, they
 don't have to be accessible
 12:14 AM Jan 8th

674. accountable, or transparent, but they can look that way."
 Leslie Savan, *Helvetica*
 12:14 AM Jan 8th

675. In *The Lady from Shanghai*, Orson Welles' O'hara, an
 Irishman, gives an incredible monologue about sharks—
 "A shark it was, then there was
 3:18 PM Jan 11th

676. another, and another shark again, and then all about the
 sea was made of sharks and more sharks still" —much
 like the Indianapolis speech
 3:19 PM Jan 11th

677. Quint, also an Irishman, gives almost thirty years later in
 Jaws. Only instead of sharks being systems that eat
 people, in *The Lady from*
 3:20 PM Jan 11th

678. *Shanghai*, sharks are people who eat each other.
 3:21 PM Jan 11th

679. When I was seventeen, I wrote: "The screen is a bond
 between viewers. It gives them something to agree on; to
 equate seeing with knowing;
 6:01 PM Jan 12th

680. to synchronize thoughts; to be on the same page, to put
 culture into people's bodies, to splice images with
 desires; to share a narrative
 6:01 PM Jan 12th

681. they don't share; to know where to put their eyes, like
 hanging a coat on a hook."
 6:02 PM Jan 12th

682. In *Don't Look Now*, Nicolas Roeg adds a red agent—an
 abstraction of death—to the image of death, which spills
 into the slide and alters what we
 6:50 PM Jan 12th

683. think we know. What we think we see.
 6:55 PM Jan 12th

684. On the elliptical language and logic of film noir: "You
 want to tell me now what it is you're trying to find out?
 You're trying to find out
 10:35 PM Jan 12th

685. what your father hired me to find out and I'm trying to
 find out why you want to find out." *The Big Sleep*
 10:35 PM Jan 12th

686. Whenever I rode my bike down Provincetown's
 Commercial Street as a kid, I was dressed in tomboy
 wardrobe and makeup: short hair, plaid
 11:55 AM Jan 13th

687. shirt, jean jacket, jeans, Adidas sneakers, walkman; a
 gender-bending, outsider ensemble I had self-consciously
 assembled based on the movie
 11:56 AM Jan 13th

688. boys I'd seen. At a young age, I understood the power and
 theater of clothing. In Provincetown, where I was allowed
 to drift relatively
 11:57 AM Jan 13th

689. unsupervised, I added music (a score) to much of what I
 did, building a mood around my excursions, cruising
 around a town full of adults,
 11:57 AM Jan 13th

690. and was aware, even then, that I was enacting a drama-
 tized (cinematic) image of aloneness. The story of girl
 solitude, which I thought I
 11:58 AM Jan 13th

691. could only play as a boy. I screened the image of aloneness for other people's benefit, which was my benefit. I was both in and outside the
11:59 AM Jan 13th

692. theater of myself.
11:59 AM Jan 13th

693. "As children of show business, we came naturally to the business of shows." Mia Farrow
3:07 PM Jan 13th

694. In *The Three Faces of Eve*, an omniscient narrator informs: "And so now Dr. Luther had three inadequate personalities to complicate and
4:16 PM Jan 13th

695. confuse his search for one stable and complete woman, all of whom continued to live, so to speak, their own separate lives. Which would it
4:17 PM Jan 13th

696. be?: The rollicking and irresponsible playgirl, the defeated wife, or the pleasant young woman, who had no memory? What, in short, had
4:18 PM Jan 13th

697. nature intended this woman to be?" It cannot be three. It must be one. Three is both too much and not enough. Three women (all
4:19 PM Jan 13th

698.　played by the remarkable Joanne Woodward), both as parts and in total, still isn't enough to make one satisfactory woman.
4:20 PM Jan 13th

699.　*The Cabinet of Dr. Caligari* is in Bernard Herrmann's score for *Psycho* and Max Steiner's *The Big Sleep* is in Elmer Bernstein's *The Grifters*.
6:00 PM Jan 13th

700.　Talking about *The Conformist* in the movie's DVD bonus features, Bernardo Bertolucci says that during filming he felt that the movie's rushes
6:31 PM Jan 13th

701.　contained: "Wild force. Chaotic, unshaped, which is always lost after editing." Bertolucci viewed editing as a form of law and order. A kind
6:32 PM Jan 13th

702.　of enforcement, which, strangely, suited the film's fascist theme. "The editing," notes Bertolucci, "gives a conformist shape to what was
6:38 PM Jan 13th

703.　beautifully wild." However, thanks to editor Franco Arcalli, *The Conformist*, says Bertolucci, is the moment when he discovered what editing
6:39 PM Jan 13th

704.　could be. Long shots interrupted by free association. "I now think," concludes Bertolucci, "*The Conformist* is a movie that came from life
6:41 PM Jan 13th

705. plus cinema."
6:45 PM Jan 13th

706. It never stops fascinating me that people in life can feel
different but act the same. In the movies, people *learn* to
act differently.
7:23 PM Jan 13th

707. As a powerful identificatory symbol and ideal love object,
viewers, as director Harold Ramis pointed out, can't help
but make John
5:11 PM Jan 14th

708. Cusack salvageable, which partly explains why Cusack is
often airbrushed in roles and why the sub-plot of Carol
Roberg, a Holocaust survivor
5:12 PM Jan 14th

709. and Roy Dillion's private nurse in *The Grifters*, was
excised from the film version. While they did keep the
character, her story and Jewish
5:13 PM Jan 14th

710. identity was left out. Screenwriter Donald Westlake
claims that the movie's "contemporary" time period
didn't permit for the inclusion of the
5:13 PM Jan 14th

711. story, but both Angelica Houston and Stephen Frears
have pointed out that time doesn't really exist in the
movie version of *The Grifters*. The
5:14 PM Jan 14th

712. movie is composed of all-time and no-time—"ambiguous time" (Frears)—a lacuna specific to America, and Los Angeles in particular. And if time
5:16 PM Jan 14th

713. is "everlasting" (Houston), or, "each face has a hundred years in it" (Cusack), then why wasn't there space in the movie's free-associative
5:16 PM Jan 14th

714. and blended chronology to include Carol? As a film, *The Grifters* gorges on American history by expressing it synchronically, and therefore
5:17 PM Jan 14th

715. in some sense not at all. History is medley. "You had the women in forties dresses," says Cusack on the movie's audio track, "and we were
5:18 PM Jan 14th

716. driving cars from the seventies, and I was in eighties suits doing my grift at a Bennigans." Even the movie's DVD cover (with Roger Ebert's
5:19 PM Jan 14th

717. twenty year old declaration that *The Grifters* is "One Of The Year's Top 10 Movies!") evokes a kind of anachronism
5:20 PM Jan 14th

718. or temporal suspension. Frears' and Westlake's removal of Carol is an attempt to save-face, primarily Cusack's face—a beloved romantic icon
5:21 PM Jan 14th

719. (*The Grifters* was released only a year after *Say Anything*).
 For, the anti-semitism Roy Dillion exhibits in the novel
 showcases a much more
 5:29 PM Jan 14th

720. unpalatable and unmarketable cruelty. A cruelty we
 would have to watch.
 5:35 PM Jan 14th

721. An anagram of "Special Features" is "Reface Use Split."
 10:28 PM Jan 14th

722. Before there were DVD audio commentaries and bonus
 features—outtakes and deleted scenes—attached to every
 movie, Richard Linklater
 12:30 PM Jan 15th

723. imagined the alternate and helical realities that the
 cinematic subjunctive could open up. In *Slacker*,
 Linklater, a character in the movie,
 12:31 PM Jan 15th

724. commences the film as an existentially rambling
 passenger in a taxicab who embarks on a long philo-
 sophical tangent about the parallel
 12:32 PM Jan 15th

725. realities of dreams that presages the DVD bonus feature:
 "Every thought you have creates its own reality..." he tells
 the silent cabdriver, "and the
 12:33 PM Jan 15th

726. thing you choose not to do fractions off and becomes its own reality...It's like when Dorothy meets the Scarecrow in *The Wizard of Oz* and
12:34 PM Jan 15th

727. they do that little dance at the crossroads and they think about going in all these different directions and then they end up going in that
12:34 PM Jan 15th

728. one direction. All those other directions, just because they thought about them, became separate realities. I mean, entirely different
12:35 PM Jan 15th

729. movies, but we'll never see it because we're kind of trapped in this one reality." Nearly 20 years later, and now we live in a new era of
12:36 PM Jan 15th

730. cinematic possibility. Cinematic subjunctive. Now every time you watch a movie you must consider what's "in" and "not" in the film. What is
12:37 PM Jan 15th

731. or could have been the story. Every movie you've ever seen must be re-seen. And every movie you've never seen should be watched twice—once
12:38 PM Jan 15th

732. without the extra features and once with them. Once with the audio commentary off and once with it on. In some ways this confirms the
12:39 PM Jan 15th

733. relationship between dream and cinema that Linklater maps out in *Slacker*. For it's possible, in the age of DVD extras, to *not* choose one road or direction.
12:40 PM Jan 15th

734. To sample all of them. To never have to choose.
12:40 PM Jan 15th

735. I think it's deeply troubling that Haiti, James Cameron, and Lady Gaga, who were all featured on *Oprah* today, share, according to Oprah and
4:02 PM Jan 15th

736. her producers, the same cultural relevance. And it's in really bad taste, if not unethical, to brag about how much money *Avatar*'s made right *after*
4:03 PM Jan 15th

737. you do a segment on Haiti needing money.
4:05 PM Jan 15th

738. I'm always moved when an actor has to change on film, especially when that change is brought upon by love. Before love and after love.
2:35 PM Jan 16th

739. In both *Rebel Without a Cause* and *East of Eden*, there's always the sense that James Dean is falling—face first—into the camera.
4:08 PM Jan 17th

740. "The dream is a priori corrupt." J. Hoberman
6:13 PM Jan 18th

741. Like Tarkovsky's *Andrei Rublev,* what's so powerful about Pasolini's *The Gospel According to St. Matthew* is its clarity. Its economy of
6:22 PM Jan 19th

742. meaning. In *The Gospel in Brief,* Leo Tolstoy writes, "To understand any book one must select the parts that are quite clear from what is
6:23 PM Jan 19th

743. obscure or confused. And from what is clear we must form our idea of the drift and spirit of the whole work." Pasolini does this not just in
6:24 PM Jan 19th

744. his reading of Matthew, but in his reading and selection of the Gospels as a whole. Taking a Goldilocks and the Three Bears –"just right" –
6:25 PM Jan 19th

745. approach, Pasolini reportedly chose Matthew because "John was too mystical, Mark too vulgar, and Luke too sentimental." Moreover,
6:26 PM Jan 19th

746. most of the film's dialogue was taken almost directly from the Gospel because Pasolini felt that "Images could never reach the poetic heights
6:27 PM Jan 19th

747. of the text." Thus, the simple declaration, "We must find a way to have [Christ] die," for example, tells us something about the *whole* of
6:28 PM Jan 19th

748. civilization.
 6:29 PM Jan 19th

749. "I've seen a lot of movies, so I know how people die." *Rage*
 8:16 PM Jan 19th

750. "A director only makes one film in his life. Then he breaks
 it into pieces and makes it again." Jean Renoir
 1:39 AM Jan 20th

751. For about twenty years, from the 1950s through the 1970s,
 the voices of male stars changed and became unsure,
 high-pitched, emotional,
 4:31 PM Jan 20th

752. choked-up, garbled, wavering, inarticulate. Men like
 Marlon Brando, James Dean, Pacino (whose own voice
 changed radically
 4:32 PM Jan 20th

753. in the 80s) had dorky, nasally, soft voices that cracked and
 caressed and symbolized a cultural shift in tone. In
 4:33 PM Jan 20th

754. *Hollywoodland,* George Reeves' (TV Superman) agent
 bitterly describes this new generation of actors as
 "mumbling and squinty-eyed."
 4:33 PM Jan 20th

755. Last night, while watching *Whatever Happened to Baby
 Jane?,* a film I find both interesting and infuriating, I
 thought about what the film
 11:51 AM Jan 21st

756. scholar Robin Wood said about Ingmar Bergman: "Bergman has constantly and consistently confused ideology with something like the human
11:51 AM Jan 21st

757. condition. The misery in which his characters generally live is seen as something unchangeable, but there is no criticism of the culture
11:52 AM Jan 21st

758. that has produced these people. It's as though everything is eternal—life has always been like this, life is always going to be like this. I'm
11:52 AM Jan 21st

759. always annoyed at the way in which you reach a point in several of [Bergman's] films where the relationship between the characters seems
11:53 AM Jan 21st

760. to be going rather well, and then, suddenly, there's a jump—everybody's miserable again, and you hardly know what's happened...We never know
11:54 AM Jan 21st

761. why everything [goes] wrong; it's just assumed that everything must." It seems, as Wood points out, that a lot of pain and confusion could
11:57 AM Jan 21st

762. be avoided or transcended by simply having characters (and people in real life) communicate vital information, not only at key moments of
11:58 AM Jan 21st

763. conflict and danger, but as a way of maintaining daily harmony and intimacy. Instead, most movies and TV shows thrive on constant, and often
11:59 AM Jan 21st

764. completely unnecessary miscommunication (or no communication at all) and suffering in order to generate and drive narrative content. What I
12:00 PM Jan 21st

765. like most about a movie like *Happy-Go-Lucky*, or a TV show like *Medium*, is that both show people actually talking — about everything — and
12:01 PM Jan 21st

766. confiding in one another. In the movies, people literally die because they can't or won't talk. Because they don't share what needs to
12:03 PM Jan 21st

767. be shared.
12:04 PM Jan 21st

768. "People dread equality. They want to establish disparity more than anything else." *The Clown*, Heinrich Böll
10:19 AM Jan 22nd

769. In Hitchcock's *Saboteur*, a truck driver tells framed man-on-the-run, Barry Kane, "I never see anything happen. I don't even hear about
12:23 PM Jan 22nd

770. anything happening, except when my wife tells me what she sees in the movie pictures." But the trucker finally gets his wish, when with his
12:23 PM Jan 22nd

771. very own eyes, he sees Barry break out of a cop car and then jump, handcuffed, off a bridge and into a river where, with the trucker's
12:26 PM Jan 22nd

772. help, Barry succeeds in escaping the police.
12:27 PM Jan 22nd

773. On "The Love Boat" with the entire Russian ballet (ballerinas) in tow, *The Dark Knight's*, Bruce Wayne, sips cocktails on the deck while
11:45 AM Jan 25th

774. surrounded by bikini-clad dancers. Batman's great cover is playboyism.
11:45 AM Jan 25th

775. In *The Dark Knight*, "We kill Batman" sounds like, "We kill Bad Man."
5:10 PM Jan 25th

776. Mel Gibson says he "feels bad" for Tiger Woods. Of course he does. In some ways, he is, and has been, Tiger Woods. In feeling bad for
10:12 PM Jan 26th

777. Woods, Gibson feels bad for Gibson.
10:12 PM Jan 26th

778. Discussing why she elected to get another 10 procedures
of plastic surgery (which reportedly took 10 hours) on
Good Morning America,
10:25 PM Jan 26th

779. Reality TV personality Heidi Montag states: "I'm in an
industry. I'm in the limelight, and I have to do what
makes me happy at the end of the
10:26 PM Jan 26th

780. day." Happiness and industry are officially one and the
same. Montag also said that her message is: "Beauty lies
within." Within what,
10:27 PM Jan 26th

781. industry? Is there even a "within" left in this country?
Within has become entirely without.
11:14 PM Jan 26th

782. Our feelings and emotions about our lives and our faces
are in other people's faces. Changing movie faces are our
feelings and emotions
11:19 PM Jan 26th

783. about our feelings and emotions.
11:20 PM Jan 26th

784. If, as Fanny Howe writes, "The face of a heart is a face,"
than all these people giving their faces away is making
me lose heart.
11:35 PM Jan 26th

785. "[Sam] Wagstaff had a certain kind of face and liked a certain
 kind of face. The *same* face. He looked for it in life and in
 11:05 AM Jan 27th

786. photographs." *Black White + Gray: A Portrait of Sam
 Wagstaff and Robert Mapplethorpe.* In the documentary *The
 Human Face,* one scientist
 11:05 AM Jan 27th

787. informs: "Our facial expressions promote facial expres-
 sions from other people."
 11:06 AM Jan 27th

788. George Orwell said that by fifty everyone has the face
 they deserve. The more I look at John Cusack, the more I
 think this is true. But is it
 8:01 PM Jan 27th

789. possible that Cusack, like many people, didn't deserve the
 once beautiful face he had in the first place?
 8:02 PM Jan 27th

790. "You're a face. Faces change." *Hollywoodland*
 11:01 PM Jan 27th

791. It's reported that after seeing Stanley Kubrick's *The
 Shining,* Rob Reiner was immediately inspired to direct a
 movie based on a Stephen King
 11:56 PM Jan 27th

792. novel. But I think Reiner's *Misery* has much more in
 common with Robert Aldrich's *Whatever Happened to Baby
 Jane?* The mis-en-scène of
 11:56 PM Jan 27th

793. captivity is very similar in both films. So is the theme of the lonely, insecure, star-struck girl-child.
 11:57 PM Jan 27th

794. In his essay on *Avatar*, "They Killed Their Mother: *Avatar* As Ideological Symptom," cultural theorist Mark Fisher writes, "What we have
 7:46 PM Jan 28th

795. in *Avatar* is another instance of corporate anti-capitalism." Similarly, Heidi Montag's above definition of inner worth as facial/body
 7:47 PM Jan 28th

796. reconstruction can be seen as corporate self-esteem.
 7:49 PM Jan 28th

797. In his blog "Bat, Bean Beam," Giovanni Tiso writes, "Whatever useful frisson there might be in a battle scene where the US marine-corps
 7:54 PM Jan 28th

798. are the bad guys (indeed, not unlike in *Soldier Blue*), they are still played by people, whereas the good guys [in *Avatar*] are simply not
 7:54 PM Jan 28th

799. there: they are computed, inserted in the afterthought of post-production, unreal." This makes me think of *Benjamin Button* again.
 7:55 PM Jan 28th

800. In *The Bicycle Thief*, down-and-out Antonio tells his small son, Bruno, "We can do anything we want because we're both men." And on that note,
8:05 PM Jan 28th

801. it takes a man to show you why you don't need a woman, or shouldn't need a woman more than you need a man. *I Love You, Man* is part of the new
8:05 PM Jan 28th

802. wave of how-to-be-a-man-again, or what kind of man *not* to be manuals (i.e., *Superbad, Knocked Up, Pineapple Express, Funny People*).
8:06 PM Jan 28th

803. You can be a guy's girl (Cameron Diaz is often described this way) or a "ladette," as the English say, but you can't be a woman's man
8:07 PM Jan 28th

804. like Peter Klaven (Paul Rudd), for men cannot and should not identify or empathize with women, the way Klaven does in *I Love You, Man*. The
8:08 PM Jan 28th

805. The backlash is mainly inflicted through language, in which everything is dick and balls and hard-ons and hairy assholes and jerking off and
8:09 PM Jan 28th

806. "cock in the head" (which could be translated as "cock on the brain" or desire for cock) and near collisions with homosexuality.
8:10 PM Jan 28th

807. Interestingly, it's not your pathological relationship to men and the male body that undermines your heterosexuality or "manhood," it's your
8:11 PM Jan 28th

808. proximity to the feminine.
8:12 PM Jan 28th

809. "It's the idea that's unbearable." *Pickpocket*
4:42 PM Jan 29th

810. This culture doesn't know how to read eyes. It always values color over content.
6:32 PM Jan 29th

811. "[Bresson] — creat[ed] performances out of reaction shots, using sound to signify offscreen events." J. Hoberman on *Pickpocket*
7:48 PM Jan 29th

812. In *Mrs. Soffel*, which sounds like *soulful*, Mel Gibson's face is threaded between prison bars, and fire and snow go together.
10:55 PM Jan 29th

813. In the subway ads for Audible.com, men read men. How about Sean Penn reads Sylvia Plath's *Bell Jar* or Jeremy Irons reads Emily Dickinson?
5:13 PM Jan 31st

814. There's something both sad and terrifying about characters in movies that can't sleep, like the men in *The Limits of Control, Man Push Cart,*
1:04 AM February 3rd

815. *The Machinist*, and *Insomnia*. Insomnia is a harbinger of male dissolution.
 1:05 AM Feb 3rd

816. In the lurid *Downloading Nancy*, Nancy and Louis' conversation in the bridal shop is literally a reenactment of an online sex chat where you
 10:39 PM Feb 3rd

817. write who you are, what you want, and what you feel, and then wait for a typed response. Where you dictate and transcribe the body (and, to
 10:40 PM Feb 3rd

818. a larger extent, reality) because you can't see, feel, or touch the body. Because the body, or reality for that matter, no longer exists.
 10:41 PM Feb 3rd

819. In *The Piano Teacher*, Erika tells Walter, her piano student, something similar, "I'll write down what you can do to me. All my desires on
 10:42 PM Feb 3rd

820. paper for you to peruse at will." But the result is vastly different. *The Piano Teacher* is a feminist rebuttal.
 10:43 PM Feb 3rd

821. "It's about time Margo realized that what's attractive onstage need not necessarily be attractive off." *All About Eve*
 1:29 AM Feb 4th

822. After watching the Turkish film *Head-On* and admiring Sibel Kekilli's serious, intelligent, beautiful face, I googled Kekilli only to discover
6:11 PM Feb 5th

823. that she's had her nose done. How disappointing and typical. It's like all the power in her face is gone. How can someone have the guts to do
6:47 PM Feb 5th

824. a film like *Head-On*—with their face (and nose!) immortalized on film—but not have the guts to keep it?
6:48 PM Feb 5th

825. "It's funny that everything is the way it is on account of the way you feel...If you didn't feel the way you do things wouldn't be the way
1:19 AM Feb 6th

826. they are...Things could be the same if things were different." *The Awful Truth*
1:20 AM Feb 6th

827. "The digital Narcissus replaces the triangular Oedipus...the clone will henceforth be your guardian angel...you will never be alone again." Baudrillard
9:42 PM Feb 7th

828. In the sci-fi *Moon*, Sam Bell (Sam Rockwell) encounters himself and discovers that there are other hims (clones), making *Moon* a film
11:47 PM Feb 7th

829. about the clone as mirror image. In the DVD extras, Rockwell notes that the mirror image is also tied to the screen persona and acting,
11:47 PM Feb 7th

830. which always results in a doubling effect. Rockwell plays both versions of Sam Bell, and when he's asked about the meaning of the film,
11:47 PM Feb 7th

831. he talks about the reality of who you are versus the fantasy of who you *think* you are and want to be. "You're not Gary Grant or George
11:48 PM Feb 7th

832. Clooney, you're *this* guy," Rockwell laughs. But Rockwell *is* that guy. He is the actor. The clone. The image ideal. Rockwell says he decided
11:48 PM Feb 7th

833. to play Sam Bell #1 as a character and Sam Bell #2 as a leading man. Similarly, when Warren Beatty asked Jack Nicholson if he would play
11:49 PM Feb 7th

834. Eugene O'Neill in *Reds*, Nicholson (who states that the only thing America knew about O'Neill at the time was his gauntness) responded by
11:50 PM Feb 7th

835. telling Beatty: "I can act anything, but I can't act thin." And Beatty replied, "But after you play O'Neill people will think O'Neill looks
11:51 PM Feb 7th

836. like you." Now if that doesn't tell us everything we need to know about the power of film and celebrity in America, I don't know what does.
11:52 PM Feb 7th

837. "Somehow the identities get all mixed up, don't they?"
It's Alive
11:59 PM Feb 7th

838. When Warren Beatty explains that he wanted Jack Nicholson to play Eugene O'Neill in *Reds* because he "sees Jack as a romantic figure," and
10:07 PM Feb 8th

839. because Jack is the only person who could "take his girl (Diane Keaton) away from him," he's lying. He chose Jack to play O'Neill because
10:08 PM Feb 8th

840. Jack's the only one who could sufficiently punish Keaton's Louise Bryant for cheating on Beatty's Jack Reed. For, as Louise tells O'Neill at
10:09 PM Feb 8th

841. one point, "You're a wounding son of a bitch and whatever I've done to you, you've made me pay for it." And that's what Jack was hired to do —
10:10 PM Feb 8th

842. wound. And that's sort of what Jack does in every role — he wounds.
10:11 PM Feb 8th

843. Just like (as Michael Pollan points out in *Food, Inc.*) the food industry still uses "The image of agrarian America...the spinning of a
6:11 PM Feb 10th

844. pastoral fantasy" to sell food, *Confessions of A Shopaholic* uses an organic and communal image of America that is free of
6:15 PM Feb 10th

845. corporate ideology, rigmarole, and rhetoric to sell life and love.
6:16 PM Feb 10th

846. In the 30s and 40s, it's almost as if skin texture didn't exist in film. Women were switched on from within like light bulbs.
5:35 PM Feb 13th

847. After watching 10 minutes of *Keeping Up with the Kardashians*, where Kourtney Kardashian brags about using mayonnaise to make her "vagina
3:03 PM Feb 14th

848. shine like the Chrysler building," I'm convinced that the horror genre has been usurped by the more garish and banal horror of Reality TV.
3:03 PM Feb 14th

849. More and more seems to mean less and less.
4:52 PM Feb 14th

850. Like Nicolas Roeg, Andrei Tarkovsky films the elemental as preternatural. And like *Don't Look Now*, in *Solaris* there is a ball that
6:09 PM Feb 14th

851. rolls in and delineates worlds.
6:10 PM Feb 14th

852. "Everything I saw before and after should be on film."
Solaris (1972)
10:54 PM Feb 14th

853. In Kenji Mizoguchi's *Ugetsu*, Tobei, in search of wealth, swears to the god of war and tells his wife, Ohama: "Ambition must be boundless as the ocean." In *Solaris*
2:05 PM Feb 16th

854. the radiated ocean, a mirror which projects our innermost desires and fears back to us, is the price we pay for that oceanic male ambition.
2:06 PM Feb 16th

855. In *Stalker*, water is also everywhere because water is both a mirror and a ruin. A repository that stores everything.
2:36 PM Feb 16th

856. In *Beauty Talk & Monsters*, I wrote a story about the way in Hollywood blonde hair often functions as a trope of beauty that isn't
5:08 PM Feb 16th

857. really there. Today on *Oprah*, a woman covered in bleached blonde hair extensions, referred to her over-the-top blonde locks as a beauty
5:10 PM Feb 16th

858. deterrent, stating, "If I have the hair, they're not going to look at me." The "not looking" is really not seeing, or seeing what (beauty)
5:11 PM Feb 16th

859. isn't there. Just like fashion labels do the work of real style, blonde hair does the work of real beauty.
5:12 PM Feb 16th

860. I want to watch *The Modernism of Julius Shulman* another five times. Just for the houses. Just for what was.
11:01 AM Feb 18th

861. In *Cries & Whispers*, the red exteriors are for us, not the female characters. The red is what's *inside* the women. Until the red finally comes out (in blood) through Karin.
11:02 AM Feb 18th

862. In *The Dark Knight*, the Joker's Grand Guignol mouth *is* the world—askew, unsalvageable. At the funhouse, the mouth is how you enter the world
2:17 PM Feb 18th

863. and is big enough to fit the entire body, leading Hal Hartley's heroine, Fay Grim (on a quest to find her fugitive ex-husband Henry Fool)
2:18 PM Feb 18th

864. to tell a Turkish Baazar shop owner: "There's always this character. The one with the big mouth."
2:19 PM Feb 18th

865. In *Who's That Knocking at My Door*, Harvey Keitel, in his film debut, is essentially playing Scorsese. He even talks like him: his rhythm,
1:22 AM Feb 19th

866. his auteurist, androcentric cinephilia.
1:22 AM Feb 19th

867. The characters in Andrei Tarkovsky's films never sound like their voices are coming out of their bodies. In fact, it's never clear what
7:07 PM Feb 20th

868. voice goes with what body.
7:08 PM Feb 20th

869. In the movie *Hollywoodland*, it is 1959 and TV's *Superman* George Reeves can be seen strapping on a sheet of rubber muscles to create the
7:17 PM Feb 20th

870. illusion of a six-pack under his slightly baggy Superman suit because in real life, Reeves (a heavy drinker and smoker) was out of shape and
7:19 PM Feb 20th

871. on pain pills. In 1959, fake was underneath fake. Fake was outside. On top of real. Fake was divisible. Today, Superman's and Batman's suits
7:19 PM Feb 20th

872. are airtight, sealed. There is less and less room for fake to hide. Not because there is less fake now, but because fake has gone inside.
7:20 PM Feb 20th

873. *Easy Virtue*: What an idiotic movie. What an idiotic face.
11:31 PM Feb 21st

874. *Paris, je t'aime* and *New York, I Love You* are omnibuses on context—people in context and people out of context. Situations in context
7:26 PM Feb 23rd

875. and situations out of context. But the two films are also trite and superficial auteurist exercises, where the viewer is invited to see what
7:27 PM Feb 23rd

876. they can and cannot identify about a director's "style," which is also an exercise in context. However, despite the theme of context, which
7:28 PM Feb 23rd

877. is supposed to add meaning, not decrease it, each vignette in both movies stays firmly on the surface. Nothing is amassed.
7:33 PM Feb 23rd

878. "Everyone thinks they shouldn't mention you to me. But I like to hear about you sometimes." *Conversations with Other Women*
11:36 AM Feb 24th

879. What have fashion models taught us? They've taught us
 that looking and wanting are not actually about desire,
 but about the industry and
 6:50 PM Feb 24th

880. marketplace of desire. You look because you should.
 Because looking at and wanting the right things are a
 6:50 PM Feb 24th

881. way of being inside.
 6:51 PM Feb 24th

882. The older I get, the more anxiety I have about language.
 Experience with it, and inexperience with making it
 work, makes post-structuralists
 7:02 PM Feb 24th

883. out of all of us.
 7:03 PM Feb 24th

884. When I was six, I saw *The Karate Kid* and was hooked.
 Ralph Macchio looked 13, but to everyone's surprise,
 even the film crew's, he was 22.
 4:57 PM Feb 25th

885. Since our bodies were the same, slight and prepubescent,
 it was easy to pretend he was 10. Like me, Ralph had no
 body hair and the waist of a
 4:59 PM Feb 25th

886. 12 year-old. On his Scorpio birthday, I cooked lasagna
 (reportedly his favorite food) and drank lemonade
 (reportedly his favorite beverage).
 5:01 PM Feb 25th

887. I even tried to sit through a hockey game on TV because
 I'd read that he loved the sport. I knew what town he
 lived in. I even knew he was
 5:03 PM Feb 25th

888. engaged. I wrote to Ralph and about Ralph in a fanzine
 that I "published" on a weekly basis and read to my
 parents (my only audience),
 5:05 PM Feb 25th

889. manufacturing my own form of press, in which I was
 simultaneously journalist and reader. I played both sides
 of the fence and covered all
 5:07 PM Feb 25th

890. bases. I acted like an intimate and I acted like a fan. I
 treated him like an actor and a person. I did what any
 good girlfriend does: I
 5:09 PM Feb 25th

891. took an active interest in the things my "boyfriend" cared
 about. I sang Ralph's praises and watched every single
 one of Ralph's movies,
 5:11 PM Feb 25th

892. aping his walk and mannerisms, and even memorizing
 his lines, so that I could talk like him, and in the process
 become not just an actor
 5:14 PM Feb 25th

893. myself—part of the fiction—but, by doing what Ralph
 did, I became Ralph. Years later, I realized that we look
 alike.
 5:17 PM Feb 25th

894. If Eli, the little vampire girl in *Let The Right One In*, grew up and became a woman, she would look like Celia Johnson in *Brief Encounter*.
8:21 PM Feb 25th

895. Oprah is all consumer (moral) relativism. Each day, she teaches people to not consume the things they were asked to consume the day before.
11:03 PM Feb 26th

896. Bertolt Brecht poem, "The Interrogation of the Good," dedicated to Oprah: "Step forward: we hear/That you are a good man/You cannot be bought
11:43 PM Feb 26th

897. but the lightning/Which strikes the house, also/Cannot be bought/You hold to what you said/But what did you say?/You are honest, you say
11:44 PM Feb 26th

898. your opinion/Which opinion?/You are brave/Against whom?/You are wise/For Whom?/You do not consider your personal advantages/Whose
11:45 PM Feb 26th

899. advantages do you consider then?/You are a good friend/Are you are also a good friend of the good people people?"
11:46 PM Feb 26th

900. In *Conversations with Other Women*, a semiotic film about the indeterminacy and unreliability of language, of image—what you don't see,
11:07 AM Feb 27th

901. what you do see; what you can't see, say, or understand—
of a single version, is conveyed through the use of a split
screen, dual-frame (no one
11:08 AM Feb 27th

902. ever really shares or can share the same symbolic space),
and that's why the director, Hans Canosa, "divides the
Panavision widescreen
11:09 AM Feb 27th

903. frame right down the middle, with one character on each
side." The "man" and "woman" are constantly recon-
structed, re-positioned, and re-
11:11 AM Feb 27th

904. narrated through alternate angles. Things are squeezed in
and squeezed out, via screen space, to see what vantage
point can actually tell us
11:12 AM Feb 27th

905. about people, about gender, about stories; about
language. About point of view. Do we see better when
things are closer or farther away?
11:13 AM Feb 27th

906. Left in, left out? Eckhart tells Bonham Carter she is "one
of those people who sees things better in the dark." He
also says, "time really
11:14 AM Feb 27th

907. can't move in two directions," which is precisely what the
movie has it doing.
11:15 AM Feb 27th

908. "The original never exists...No one came before the
 other." Israeli Filmmaker, Udi Aloni
 12:08 PM Feb 27th

909. I wonder if the obsession with women—especially
 models and actresses—being a size zero is similar to what
 Slavoj Zizek refers to as the
 10:28 PM Feb 27th

910. gradual exclusion and erosion of the Other. "A kind of
 mockingly Hegelian negation of negation, [where] the
 very dimension of otherness
 10:28 PM Feb 27th

911. is cancelled." Or, in the case of the size Zero woman,
 hollowed out, so that only an outline of Her remains.
 10:31 PM Feb 27th

912. "Stay down." *Cool Hand Luke*
 11:49 PM Feb 27th

913. "Machines are developed to meet situations." *Fail-Safe*
 2:26 AM Feb 28th

914. The atomic bomb, tested two times (once above water and
 once below water) on the Pacific island of Bikini Atoll, is
 truly one of the most
 2:08 AM Feb 28th

915. important metaphors for American history and society,
 which always thinks (i.e., 9/11) of the immediate
 spectacle of the explosion—never
 2:14 AM Feb 28th

916. the fallout. In "Divine Violence," Slavoj Zizek discusses Peter Sloterdijk's proposal for an "alternative history of the West as the history
2:15 AM Feb 28th

917. of *rage*...The entire Messianic logic of rage-concentration and total revenge that exploded with Judeo-Christianity." "What is crucial in this
2:15 AM Feb 28th

918. position," Zizek goes on to say, "is the later monotheistic, Judeo-Christian mutation of rage (mutation also applies to the bomb's
2:15 AM Feb 28th

919. radioactive side-effects, my addition). While in ancient Greece rage is allowed to explode directly, what follows is its sublimation, temporal deferral,
2:16 AM Feb 28th

920. postponement, transference" (*Radio Bikini* opens with President Truman delivering the following statement about the atomic
2:16 AM Feb 28th

921. bomb: "It is a harnessing of the basic power of the universe. We thank God that it has come to us, instead of to our enemies, and we pray
2:16 AM Feb 28th

922. that he may guide us to use it in his ways and for his purposes." Thus the universe's basic power is even *harnessed* as rage and total
2:17 AM Feb 28th

923. revenge). One could argue that the two-part atomic test
 that took place on Bikini in 1946, and which
 2:17 AM Feb 28th

924. Robert Stone recreated using archival footage in his 1988
 documentary *Radio Bikini*, is an enactment and
 2:17 AM Feb 28th

925. staging of this Judeo-Christian mutation. The first bomb
 is in some ways an explicit and direct explosion of rage-
 concentration—although it
 2:17 AM Feb 28th

926. wasn't presented that way to the Marshal islanders who
 were moved from their island en masse—and the second
 (underwater) explosion is
 2:18 AM Feb 28th

927. followed by its ultimate sublimation, "temporal deferral
 and postponement" in the form of a silent and symboli-
 cally bottomless sea and
 2:18 AM Feb 28th

928. the slow-burning and long-lasting (time-release)
 radioactive fallout that spanned a period of 40 years.
 From the get-go, the atom
 2:18 AM Feb 28th

929. bomb, witnessed by US navy sailors, and appraised for
 its entertainment value like some Hollywood block-
 buster, was deemed a huge
 2:19 AM Feb 28th

930. box-office disappointment: "It was a pretty poor spectacle," one soldier bemoaned, as the surface (and what besides the surface has ever
2:19 AM Feb 28th

931. interested America?) of the water and sky kept up appearances by remaining perfectly calm and perfectly clear.
2:20 AM Feb 28th

932. In Martin Scorsese's *Shutter Island*, three important things are said (we're back to the atom bomb as the specter of history; as
10:37 AM Feb 28th

933. rage concentration): "God loves violence." "Can my violence conquer your violence?" "We've known each other for centuries." After this, the
10:39 AM Feb 28th

934. film collapses.
10:41 AM Feb 28th

935. "You remember that scene on the island where they tested an atom bomb? There were these big turtles, you know tortoises, who at a certain
3:42 PM Feb 28th

936. time in their lives would walk to the sea to lay their eggs. And they found that the radiation threw the turtle's sense of direction, so
3:42 PM Feb 28th

937. instead of heading to the sea, they went inland and they
 died...Somebody took those movies...Do you think, after
 they took those movies,
 3:43 PM Feb 28th

938. they reached down and turned those turtles around? Or
 did they put them in a jeep and drive them back?"
 Medium Cool
 3:44 PM Feb 28th

939. "The reason people are so passive toward the dangers of
 war lies in the fact that the majority just do not love life."
 Erich Fromm
 5:01 PM Feb 28th

940. Director of *Children of Men*, Alfonso Cuaron: "Many of the
 stories of the future involve something like 'Big Brother,'
 but I think that's a
 8:17 PM Feb 28th

941. 20th C. view of tyranny. The tyranny happening now is
 taking new disguises—the tyranny of the 21st C. is called
 'democracy.'" L. Ron
 8:18 PM Feb 28th

942. Hubbard: "If you really want to enslave people, tell them
 that you're going to give them total freedom."
 8:19 PM Feb 28th

943. *Shutter Island* can be summed up by this line from Allen
 Ginsberg's *Howl*: "All that bad karma has to go
 somewhere."
 7:18 PM March 1st

944. "Where does her bad half go?" *Sisters* (1973)
11:33 PM Mar 1st

945. The lyric, "In my room. In your room" by the Yeah Yeah Yeahs reminds me of *Pretty in Pink.* The movie; the soundtrack.
11:43 PM Mar 1st

946. After my tweet about *Pretty in Pink* and the Yeah, Yeah, Yeahs yesterday, I read an interview with the lead singer, Karen O. In it she states:
11:56 PM Mar 1st

947. "We've got a death grip on the adolescent way of feeling things. It almost feels like a John Hughes 80s movie."
11:57 PM Mar 1st

948. "It's much more intimate to make out [in movies] than it is to simulate sex because there is no difference between the way people kiss in
11:31 PM Mar 2nd

949. life and the way they kiss in movies. But there's a big difference between the way that you have sex in life and the way you do in
11:32 PM Mar 2nd

950. movies." Peter Sarsgaard
11:32 PM Mar 2nd

951. In Catherine Breillat's *Sex is Comedy*, female director, Jeanne, offers this about acting and the body: "Your ass in a sex scene is your ass."
11:35 PM Mar 2nd

952. In *Five Easy Pieces*, Jack Nicholson has green eyes. Has this always been the case?
12:04 AM March 3rd

953. When Penelope Cruz asks Halle Barry what movie she likes to watch over and over again on Oprah's Oscar special, Berry says *Fatal Attraction*.
12:13 AM Mar 4th

954. Then, later in the show, Glenn Close and Michael Douglas "reunite" to share their nostalgia about making *Fatal Attraction*, as if the movie
12:13 AM Mar 4th

955. were some true romance. How sad for Berry and Oprah and Glenn. When *Fatal Attraction* came out, and continued to attract record crowds,
12:14 AM Mar 4th

956. director Adrian Lyne gushed, "It's amazing what an audience-participation film it's turned out to be. Everybody's yelling and shouting and
12:14 AM Mar 4th

957. really getting into it. This is a film that everyone can identify with. Everyone knows a girl like Alex." "Everyone" being men because in
12:15 AM Mar 4th

958. 1987, when *Fatal Attraction* was released, male movie-goers were reportedly shouting homicidal phrases like, "Punch the bitch's face in," and,
12:15 AM Mar 4th

959. "Do it, Michael. Kill her already. Kill the bitch" at the screen. In her book *Backlash*, Susan Faludi writes that a female teenage usher named
12:16 AM Mar 4th

960. Sabrina Hughes reported that in 1987 the men in the audience would scream things like, "Beat that bitch! Kill her off now!" while "women
12:16 AM Mar 4th

961. would 'just si[t] there, real quiet.'" "Soon after *Fatal Attraction's* triumph," writes Faludi, "Lyne announced plans for another film about
12:16 AM Mar 4th

962. a literally mute black prostitute who falls for a white doctor. The working title, he said, was *Silence*." Originally, *Fatal Attraction* was
12:16 AM Mar 4th

963. "supposed to end with Alex Forrest in deep despair over her unrequited love. Committing suicide by slashing her throat to the music of
12:17 AM Mar 4th

964. Madame Butterfly," writes Faludi. But this ending fell flat with test audiences—who didn't find it "cathartic" enough—and was swapped for the
12:17 AM Mar 4th

965. now famous bathtub ending. When Kirk Douglas' (Michael Douglas' father) suicide attempt fails in Elia Kazan's *The Arrangement* (1969), (which
12:18 AM Mar 4th

966. reminds me of *The Swimmer*, released a year before), a psychiatrist tells Douglas' wife (Deborah Kerr in her last film): "In every suicide
12:20 AM Mar 4th

967. there is an element of revenge." This is arguably the reason why having Alex commit suicide failed to deliver the misogynistic catharsis
12:23 AM Mar 4th

968. audiences were looking for.
12:24 AM Mar 4th

969. "Early on someone told me, 'You know, the camera can always tell when you're lying.' The camera can always tell? How am I going to do
7:43 PM Mar 4th

970. this? Until one day I thought, wait a minute, acting is lying. Acting is all about lying. And hey, I've lied to my mother, I've lied to
7:44 PM Mar 4th

971. girls—'Oh, baby, baby' - I can be a great liar. So who's to know if I'm telling the truth on screen?'" Michael Douglas
7:45 PM Mar 4th

972. "The screwing I'm getting is not worth the screwing I'm getting." Faye Dunaway in *The Arrangement* (1969)
1:43 AM Mar 5th

973. "Couldn't the entire history of humanity be seen as a growing normalization of injustice?" Slavoj Zizek
1:01 PM Mar 5th

974. Is the long corridor that Kirk Douglas runs through over and over, in fast motion (away from the camera) in Elia Kazan's *The Arrangement*
1:35 PM Mar 5th

975. (1969), the same corridor that Lee Marvin walks through (towards the camera) in *Point Blank* (1967)?; his spectral heels pounding louder and
1:36 PM Mar 5th

976. louder against the pavement.
1:38 PM Mar 5th

977. Despite its ubiquity, movie star plastic surgery is inherently strange since actors are known for their faces. To change one's face when
6:29 PM Mar 5th

978. everyone knows your face (when the amount of people who know your face equals the size of your fame) is to be known as someone else while
6:30 PM Mar 5th

979. still being you. Instead of the fiction of character, it's now the fiction of the face.
6:31 PM Mar 5th

980. Private eyes from the future are always from the past.
1:48 PM Mar 7th

981. In *Marley & Me* (an *E. T.* for the new millennium), Marley, John's (Owen Wilson) beloved dog and confidant, is really John. The restless,
5:01 PM Mar 7th

982. rootless John is never sure that his life has meaning, so whenever John tells Marley that he loves him, that Marley's life means something,
5:03 PM Mar 7th

983. that Marley's life holds infinite value and purpose, he is really saying that *his* life has value and purpose. And when Marley is put to sleep
5:04 PM Mar 7th

984. due to old age, and John whispers into Marley's ear, "I love you more than anything" (more than even his wife and children apparently. The
5:05 PM Mar 7th

985. film's title alone suggests the family's exclusion), John is really saying that he loves himself—his primal, infantile, unsocialized
5:06 PM Mar 7th

986. (boy)self—more than anything.
5:07 PM Mar 7th

987. In *The Tao of Steve*, Syd, a set designer for Don Giovanni, and the only woman Dex has ever fallen in love with, tells Dex, "Don Giovanni
5:37 PM Mar 12th

988. slept with thousands of women because he was afraid he wouldn't be loved by *one*." In *Lonesome Jim*, misanthropic loser, Jim, gets the girl
5:38 PM Mar 12th

989. without transforming in any way. In *Up in the Air* Ryan
 Bingham (George Clooney) is gaslit completely out of the
 blue by Vera Fermiga's Alex
 5:39 PM Mar 12th

990. Goran as a way to prove that women can't be trusted and
 that love doesn't exist. I think it's time to admit that like
 homophobia,
 5:40 PM Mar 12th

991. as Sarah Schulman argues in her book, *Ties That Bind:
 Familial Homophobia and Its Consequences,* sexism is a
 5:41 PM Mar 12th

992. pleasure system, not a pain system. Which means that
 contrary to what our culture teaches us, Don Giovanni,
 Dex, and Ryan sleep with and
 5:41 PM Mar 12th

993. discard "hundreds" of women, not because they're afraid
 they won't be loved, as Syd points out, but because they
 don't *want* or *need* to
 5:42 PM Mar 12th

994. love. In *The Art of Loving,* Erich Fromm writes: "While one
 is *consciously* afraid of not being loved, the real, though
 usually *unconscious*
 5:44 PM Mar 12th

995. fear, is that of loving." There are simply more cultural and
 social rewards for not loving or valuing women, which is
 why when Larry David
 5:45 PM Mar 12th

996. declares himself a "misogynist" on Jerry Seinfeld's new
 TV show, *The Marriage Ref*, everyone laughs and cheers.
 In *Fantastic Mr. Fox*, Mrs. Fox
 5:46 PM Mar 12th

997. tells her solipsistic and myopic husband, Mr. Fox (also
 George Clooney), "In the end we all die unless you
 change," or as bell hooks puts it
 5:47 PM Mar 12th

998. in *Outlaw Culture*: "White man, you're going to have to
 look at yourself with some degree of critical thought if
 you are to experience any
 5:48 PM Mar 12th

999. love at all."
 5:49 PM Mar 12th

1000. In a TV interview with Cinemascope in 1980, François
 Truffaut admitted that he felt dissatisfied with *Love on the
 Run*, the final film in the
 8:11 PM Mar 12th

1001. Antoine Doinel cycle. Truffaut lamented that he hadn't
 succeeded in letting Antoine evolve. That Antoine
 became fixed like "a cartoon
 8:12 PM Mar 12th

1002. character...Mickey Mouse can't grow old." Antoine is an
 evolution without the evolution. "Perhaps the Doinel
 cycle," notes Truffaut, "is the
 8:13 PM Mar 12th

1003. story of failure."
8:14 PM Mar 12th

1004. *The Tao of Steve* only confirms what I've always suspected: books can't change people who aren't already capable of learning or changing.
5:53 PM Mar 13th

1005. Womanizer Dex is surrounded by philosophical texts that he apparently knows inside out, and yet he never demonstrates any actual signs of
5:54 PM Mar 13th

1006. knowing. There is no integration between what he reads and what he does. Dex doesn't think; he schemes, using what he's read as bait to lure
5:55 PM Mar 13th

1007. women. Dex takes what he reads and turns it into stock answers. Confuses sexist plotting with knowledge and "enlightenment;" a disconnect our
5:56 PM Mar 13th

1008. culture increasingly makes possible. In Hal Hartley's *Surviving Desire*, Martin Donovan's Jude, an English professor, ponders at length about
5:57 PM Mar 13th

1009. the limitations of reading: what reading can and cannot do; the gap between knowing and being; theory and practice: "The things you're
5:58 PM Mar 13th

1010. reading are having an effect on you," Jude tells Sophie, his love object, at the bookstore where she works. Jude and Sophie are literally
5:59 PM Mar 13th

1011. surrounded by books. "I read. I understand and I appreciate," says Jude, "but still I'm left unchanged. I can't put into action what it is I
5:59 PM Mar 13th

1012. understand...Books don't help." Upon discovering the holy grail of secret libraries in Truffaut's *Fahrenheit 451*, the Fire Captain and book
6:00 PM Mar 13th

1013. burner/censor tells the suddenly book-curious book burner Guy Montag, "[The books] make people want to live in other ways. Ways they can
6:01 PM Mar 13th

1014. never really be." But the truth, as I've come to see it, is that books can only tell us what we're already prepared and willing to understand.
6:02 PM Mar 13th

1015. With regards to the recent Armond White/Noah Baumbach scandal (whose films I can't stand), one of things I like about what film critic Armond
7:47 PM Mar 13th

1016. White (who still believes in the politics of representation, but doesn't always practice it in his criticism) said is
7:48 PM Mar 13th

1017. precisely what everyone else has taken issue with. The fact that for White the personal is still political and vice versa. So saying:
7:49 PM Mar 13th

1018. "Look at [Baumbach's] movies. You're aware of what D.H. Lawrence said about writing...? Trust the tale, not the teller. So, Wes Anderson and
7:51 PM Mar 13th

1019. Noah Baumbach, they can tell you what they believe they're about. They can get on a podium and say, 'This is what I
7:52 PM Mar 13th

1020. believe in, this is what I feel, this is what I love, this is what I dislike...' Can't trust any of that. You've got to look at the movie.
7:53 PM Mar 13th

1021. You look at Noah Baumbach's work, and you see he's an asshole'" is very much connected to White's earlier comment: "The problem I see in
7:54 PM Mar 13th

1022. criticism is lots of criticism is written by people who don't think, don't even know who they are. For white folks it's very easy...That's
7:55 PM Mar 13th

1023. the problem with a lot of film criticism, a lot of casual people writing, pretending that they know what they're talking about, pretending
7:56 PM Mar 13th

1024. that they know the way the world works. They're white, they can afford to keep things okey-dokey, status quo," which really means that it
7:57 PM Mar 13th

1025. is a privilege *not* to consider or, in some cases even acknowledge, the filmmaker behind the film. To suggest that representation is
7:59 PM Mar 13th

1026. isn't part of a larger system. Like Foucault, White is saying that the privilege of aestheticization, of being "apolitical;" of orphaning
8:00 PM Mar 13th

1027. cultural production, is just that, a privilege. The tale tells us who the teller is as well as who the teller doesn't even *know* he is.
8:01 PM Mar 13th

1028. In *Funny Games*, the two middle-class teenage killers are dressed in white. *In a Clockwork Orange*, the gang of middle-class killers are
11:03 PM Mar 14th

1029. also dressed in white.
11:04 PM Mar 14th

1030. When Jack Nicholson pulls Jessica Lange's underwear to the side in the 1981 remake of *The Postman Always Rings Twice*, Lange actually has pubic
11:48 PM Mar 14th

1031. hair that spills out between her legs, which means Lange/Kora is not a faux-woman, but an actual woman with seams, which means there is some
11:49 PM Mar 14th

1032. actual sexuality and power at play, something real and undoctored between Kora's legs.
11:51 PM Mar 14th

1033. Why does Hi-Definition make everything look like live TV? *Blade Runner* looks like *Law & Order*.
9:07 PM Mar 15th

1034. We need multiple narratives to contend with multiple narratives. The media gives us one and pretends it speaks for everyone. The way Reality TV shows refer to "America" as a single entity/arbiter.
10:16 PM Mar 15th

1035. While in *Kate & Leopold*, Leopold's time-travel into the future is just an excuse to return career-woman Kate to a career-less, pre-feminist
11:17 PM Mar 15th

1036. past, *Time After Time* (1979) is all about transcending the vertigo of time by finding kinship with time, which is also about gender. Things
11:18 PM Mar 15th

1037. take time, change takes time; people are often out of time, "until [they] master [themselves] [they] have no proper use for time." In *Time After*
11:19 PM Mar 15th

1038. *Time*, career woman and au courant, Amy Robbins, brings H.G. Wells to the Big Basin Redwoods State Park in California, the way Kim Novak
11:20 PM Mar 15th

1039. took Jimmy Stewart in *Vertigo*. In *Vertigo*, Novak's Judy Barton points to the tree-rings of time to locate herself. In *Time After Time*, a
11:21 PM Mar 15th

1040. Hitchockian (even the music recalls Bernard Herrmann's score for *Vertigo*) detective/time travel/love story, Amy isn't reconstructed
11:23 PM Mar 15th

1041. or made-over or turned into a fetish object. Instead, she presents herself exactly as she is and wants to be in time, so that the Redwoods
11:24 PM Mar 15th

1042. scene in *Vertigo* takes on a totally different meaning in *Time After Time*. But when the time finally does come for Wells to go back in time
11:25 PM Mar 15th

1043. to write books, "whatever they are," Amy changes her mind at the last minute, opting instead to pay lip service to feminism by changing her
11:26 PM Mar 15th

1044. name to Susan B. Anthony. Amy gives up her commitment to her present for Wells' future. Men don't go forward. Women go back.
11:28 PM Mar 15th

1045. "[As] you become more successful, and people say, 'She's really pretty,' You realize your looks haven't changed; it's the way people are
9:07 AM Mar 16th

1046. perceiving you.'" Julianne Moore on becoming beautiful through film.
9:08 AM Mar 16th

1047. The night George Romero finished *Night of the Living Dead*, and threw the film reel in the trunk of his car to sell in New York is the
7:11 PM Mar 17th

1048. night that Martin Luther King Jr. was assassinated. Coincidentally, the last montage in *Night of the Living Dead* ends
7:12 PM Mar 17th

1049. with the execution-style murder of the film's black hero, Ben.
7:13 PM Mar 17th

1050. In the movies, everyone always knows where everything is...and can get there.
9:18 AM Mar 18th

1051. Clothing designer Tom Ford's *A Single Man* is shallow and pretentious. It's fashion masquerading as grief. Everything looks good
3:41 PM Mar 19th

1052. even when everything feels bad. Ford hasn't made a film, he's *designed* a film. The movie isn't about the way life is, or was, but the
3:42 PM Mar 19th

1053. way life looks or looked.
3:43 PM Mar 19th

1054. "We kept on sailing through a sea of cameras." Mia Farrow on her relationship with Frank Sinatra
2:49 PM Mar 20th

1055. In *The Wedding Dress*, Fanny Howe writes: "What you desire is what creates quality. You are not made by yourself, but by the thing you want."
6:38 PM Mar 20th

1056. The documentary *Dominick Dunne: After the Party* is an allegory on fame, as is Dunne's life. *After the party* is an apt title, as it
8:05 PM Mar 21st

1057. suggests that life begins when we give up facade, which is what fame and obsession with fame is. Star worship barricaded Dunne from
8:06 PM Mar 21st

1058. himself and from real intimacy with others. Fame is a metaphor for not-knowing. For knowing everyone, is really knowing no one, and being
8:07 PM Mar 21st

1059. known by everyone is really being known by no one.
 Dunne spent half of his life celebrating this principle.
 Parties became the expression of
 8:08 PM Mar 21st

1060. this ethos. When the party stopped, Dunne lost every-
 thing, moved to a cabin in Oregon, and in his hermitage,
 began to write. His solitude
 8:10 PM Mar 21st

1061. culminated in a life of writing, which Dunne points out,
 you do by yourself. In an essay on Michael Haneke's
 Benny's Video, Robin Wood
 8:11 PM Mar 21st

1062. writes, "At last Benny is looking at himself, so that he can
 see who he is." Dunne learned to do this by being alone
 and by writing. In *8 ½*,
 8:12 PM Mar 21st

1063. Guido's producer reminds Guido of Mallarme's oath of
 silence. In Hal Hartley's *Surviving Desire*, Jude says, "You
 must withdraw from life. To
 8:13 PM Mar 21st

1064. know about life sometimes you have to step away from
 it." And Morrissey once observed that being at the center
 of things can be dangerous.
 8:14 PM Mar 21st

1065. "My head is full of stars." *A Hundred and One Nights*
 9:01 AM Mar 22nd

1066. I think *Dawn of the Dead* and *The Road* have something in common. The shopping mall is the matrix of America.
11:49 PM Mar 23rd

1067. "The greater the truth, the greater the damage..." "He is telling the truth and the more truth he tells, the worse it gets"..."It's not the fucking
12:01 AM Mar 24th

1068. point whether you tell the truth or not." *The Insider's* bleak narrative arc on truth. All of Mann's silver foxes—William Peterson in
12:02 AM Mar 24th

1069. *Manhunter*, De Niro in *Heat*, Crowe in *The Insider*, and Cruise in *Collateral*—form an arc as well.
12:11 AM Mar 24th

1070. "Hello Frank. How's my favorite writer? Frank, people in this country are busy and broke and they hate to read and they need someone they
7:33 PM Mar 25th

1071. can trust to say, 'Hey, don't watch *CSI: Indianapolis* tonight. Read a book. Read Frank's book. And that person is Oprah.'" *The Proposal*
7:34 PM Mar 25th

1072. In an interview between the conceptual Russian artist, Irina Nakhova, and the art historian/curator, Margarita Tupitsyn, Nakhova, quoting
8:36 PM Mar 26th

1073. Russian artist and collaborator, Viktor Pivovarov, states: "Art is your life and if you create something, you have to do it only out of
8:37 PM Mar 26th

1074. extreme necessity. Otherwise, artworks simply clutter up the world." This idea relates to what I've long referred to as compulsive
8:38 PM Mar 26th

1075. creativity; the kind that's more about surplus than necessity. Nakhova: "I would call it a critical attitude, given the
8:39 PM Mar 26th

1076. zombification of the creative personality by the mass media, to the point of the complete emasculation of any critical attitude and
8:40 PM Mar 26th

1077. independent thought among young people...After all, there's nothing more important than feeling that you're a thinking person, and not
8:42 PM Mar 26th

1078. losing awareness of what's happening around you." Margarita Tupitsyn: "In other words, what the Soviet regime used to do is now being done
8:43 PM Mar 26th

1079. by the Western media, but more successfully. Strangely enough, under the repressive Soviet system, there were more freethinkers." Funny,
8:45 PM Mar 26th

1080. this means that "losing awareness of what's happening around you," as Nakhova puts it, is either a form of catatonia or State-induced
8:46 PM Mar 26th

1081. zombification. How perfect, then, that I should have George Romero's *Dawn of The Dead* at home right now. An amalgam of both.
8:47 PM Mar 26th

1082. "I avoided other people like they were zombies even before they were zombies. Now that they're all zombies, I kind of miss people." *Zombieland*
11:01 PM Mar 27th

1083. "You don't get body without society and you don't get society without body." David Cronenberg in *The American Nightmare*
4:14 PM Mar 28th

1084. In the documentary *The American Nightmare*, film scholar Carol Clover discusses the horror movie *Halloween* and says: "We see ourselves
9:42 AM Mar 29th

1085. holding a knife and stabbing someone and we don't know who we are. We don't know who we are."
9:43 AM Mar 29th

1086. Horror is interesting because the body is being transgressed all the time — your body, someone else's body. The monster's body. In horror,
5:09 PM April 1st

1087. the body ceases to be hermetic and is pierced, penetrated, pushed through, opened, dissolved; entered and exited in every way. Its
5:10 PM Apr 1st

1088. social seal is ripped right off. All of David Cronenberg's films are about this.
5:11 PM Apr 1st

1089. In *Carrie*, Pino Donaggio finishes what Bernard Herrmann started in *Sisters*: The score of taunting. The horror of difference.
1:50 PM Apr 2nd

1090. I think Elia Kazan's *The Arrangement*, starring Kirk Douglas, is largely about life as it's told through the movies. The Hollywoodization
2:19 PM Apr 3rd

1091. of life, the way life looks on film, or *because* of film (Fellini's *8 ½* also examines the life-as-film idea), and so is Tom Ford's
2:20 PM Apr 3rd

1092. *A Single Man*. Only Kazan was looking at this phenomenon critically, while Ford doesn't know any alternative. He *is* that phenomenon. As Faye
2:21 PM Apr 3rd

1093. Dunaway tells ad exec/lover Douglas: "The fact is you don't know what's false and what's true anymore. You only know what will sell."
2:23 PM Apr 3rd

1094. Sydney Pollack was interested in Mozart. Max von Sydow's hitman listens to Mozart's Concerto for clarinet and orchestra in A (K.622) in
11:57 PM Apr 4th

1095. *Three Days of The Condor* and so does Robert Redford's loner Finch Hatton in *Out of Africa*.
11:58 PM Apr 4th

1096. "How can it be not exactly him if it *is* him?" *Flesh for Frankenstein*
12:38 PM Apr 5th

1097. @RoxyHoliday despairs back and forth with John Cusack that he and his tweets are "nothing" like she imagined them to be—a testament to just
7:50 PM Apr 6th

1098. how powerful Cusack's screen mythology really is, how deep Cusackian lore goes, and the reason why I'm writing a book about it. Cusack
7:51 PM Apr 6th

1099. responds (via Twitter) repeatedly with defensive retorts like: "see i find that to be so interesteing - since i am me...i wonder how i was
7:52 PM Apr 6th

1100. supposed to do a better job at being myself....any suggestions ?" (typos are Cusack's). RoxyHoliday says Hollywood convinced her
7:53 PM Apr 6th

1101. that Cusack was someone different, but I think he's played a big part in that confusion too.
7:54 PM Apr 6th

1102. "I wish someone would tell me about me." *All About Eve*
10:05 PM Apr 6th

1103. "The basic thesis of *The Age of Innocence* is that there is nothing sadder than giving up on love. Worse than avoiding it or being denied it
11:34 PM Apr 6th

1104. is surrendering it yourself. Edith Wharton characters are constantly doing this, and Wharton's genius was to propose it as a uniquely American
11:36 PM Apr 6th

1105. form of tragedy." Molly Young
11:37 PM Apr 6th

1106. "What we put between us, we can remove." *Fail-Safe*
9:08 AM Apr 7th

1107. "Movies are a conspiracy. They set you up to believe in everything...In ideals and strength and romance, and of course, love. Love. You
4:38 PM Apr 7th

1108. believe it, you go out, you start looking. Doesn't happen, you keep looking. The movies set you up. They set you up, and no matter how
4:40 PM Apr 7th

1109. bright you are, you believe it." Gena Rowlands in *Minnie & Moskowitz*
4:41 PM Apr 7th

1110. People (including Cassavetes himself) always say that John Cassavetes' movies are all about love: "Love is hard, love is difficult,
4:48 PM Apr 7th

1111. love is necessary," Peter Falk (a Cassavetes staple) once noted. In *Minnie & Moskowitz*, Minnie goes to the movies with a female co-worker,
4:49 PM Apr 7th

1112. then later that night, drunk and lovelorn, declares that movies teach people to believe in things that don't exist— namely love and a certain
4:50 PM Apr 7th

1113. kind of romantic (cinematic) hero. Both Minnie and Moskowitz are avid moviegoers. They live in Los Angeles and watch old movies like *The*
4:51 PM Apr 7th

1114. *Maltese Falcon* and worship Humphrey Bogart. But neither of them have managed to find what they see on screen. We see a series of men
4:52 PM Apr 7th

1115. (one of them is Cassavetes, Gena Rowlands' real-life husband, who plays Minnie's abusive lover) make life/love impossible for Minnie. Thus,
4:53 PM Apr 7th

1116. the cinematic spell of love is shaken out of the movies, this movie. Minnie. The screen comes loose. *Minnie & Moskowitz* is a movie about
4:54 PM Apr 7th

1117. everyday people having to live with the intangibilities and fallout of romantic illusion—an illusion augmented and complicated by movies.
4:55 PM Apr 7th

1118. "Have you ever made someone happy? Is there a single person you have made happy?" *Code Unknown*
10:00 PM Apr 7th

1119. *Hot Tub Time Machine's* 80s "homage" (aggressively promoted by Cusack, who's been shunning his 80s past for years) ironically marks the end
8:03 PM Apr 8th

1120. of every anti-80s movie (and sentiment) Cusack ever made, resisted making, and denounced in the 80s. Through its sheer hysterical misogyny,
8:04 PM Apr 8th

1121. mania, nihilism, vulgarity, *HTTM* negates everything interesting, hopeful, and meaningful Cusack *did* manage to do and say in the 80s.
8:05 PM Apr 8th

1122. The *Sex and the City 2* trailer reveals that the awful sequel to the awful TV show & movie is some kind of awful mix of *Dynasty* and *Sahara*.
11:17 PM Apr 9th

1123. There is a scene (in a boat) in *The Deep* between Robert Shaw and Nick Nolte that could easily be a scene (in a boat) between Shaw and Roy
11:24 PM Apr 10th

1124. Scheider in *Jaws*. Only instead of a shark underwater, we have ampoules of heroin.
11:25 PM Apr 10th

1125. When Nadya Suleman ("Octo Mom") says she has "absolutely never had plastic surgery" when she absolutely has, and there are images to prove
4:13 PM Apr 11th

1126. that she used to look absolutely different, she absolutely loses credibility about everything else she claims to do and not do. Want and not
4:14 PM Apr 11th

1127. want. And if this is true—if images don't actually tell us anything; if they don't correlate to any kind of actual reality—then images are
4:15 PM Apr 11th

1128. simply chimeras, so maybe we should stop believing in them so much and come up with something better to do with our time.
4:16 PM Apr 11th

1129. In her memoir *What Falls Away*, Mia Farrow describes Woody Allen's *Hannah and Her Sisters* script as: "The script was wordy, but it said
5:42 PM Apr 12th

1130. nothing." Barbara Kruger's new video installation at Mary Boone, "The Globe Shrinks," which features a variety of instructions (one of them,
5:43 PM Apr 12th

1131. "Doubt It") could be described the same way. I left the gallery thinking, we believe because we *don't* believe. Non-belief (doubt), like the
5:45 PM Apr 12th

1132. eponymous play and movie, *is* the new belief. We believe in what we don't believe and in what we can fake (see Reality TV and the movie *Pretty*
5:46 PM Apr 12th

1133. *Persuasion*). Yet somehow Kruger's installation is as hollow as the hollowness she's critiquing. These days, critiques of kitsch simply
5:47 PM Apr 12th

1134. result in more kitsch. It didn't always. I asked my mother (the art historian and curator Margarita Tupitsyn) why she thinks Kruger's critique
5:48 PM Apr 12th

1135. rings so hollow, and she replied: "Artists today don't know how to find the proper form to express radical ideas. Instead, they appropriate
6:00 PM Apr 12th

1136. existing forms—readymades from the media. But since the media has de-radicalized everything, one has to once again find and invent forms
6:01 PM Apr 12th

1137. that the media hasn't yet exhausted, like Marcel Duchamp did with his fountain in the 1920s."
6:04 PM Apr 12th

1138. "Once he wins, things will start to change. Winning takes care of a lot of problems." Donald Trump on Tiger Woods
3:12 PM Apr 13th

1139. "Me? I'm with me." *On the Waterfront*
6:08 PM Apr 14th

1140. In response to her recent breakup, Melissa Etheridge writes a song and an album called "Fearless Love," stating: "How can I love anyone
4:11 PM Apr 15th

1141. unless I'm *TOTALLY* in love with myself?" Is this what we've come to believe love is? Being "*TOTALLY*" in love with oneself? Like such a thing
4:12 PM Apr 15th

1142. even exists, and if it does, it's called narcissism. In that case, Etheridge should call her album "Fearless Narcissism."
4:13 PM Apr 15th

1143. *The Lovely Bones* can be read as CGI pedophilia. Like *The Exorcist*, Susie's rape and murder coincides with her puberty and
9:26 PM Apr 16th

1144. interest in sex. To quote Roger Ebert: "This whole film is Peter Jackson's fault."
9:27 PM Apr 16th

1145. When Katherine Heigl's character is given a vibrator to use in *The Ugly Truth*, she declines, stating: "Masturbation is so impersonal." In
5:39 PM Apr 17th

1146. the windows of Soho's Armani Exchange, fashion ads for the line show men and women half kissing their look-alikes, half looking at them-
5:40 PM Apr 17th

1147. selves in the mirror. Ironically, there is no *exchange*. Analyzing England's 2006 first "masturbate-a-thon," in "Sexuality in the Atonal
5:41 PM Apr 17th

1148. World," Slavoj Zizek asks: "What kind of sexuality fits this universe?" The event, writes Zizek, "builds a collective out of individuals who
5:42 PM Apr 17th

1149. are ready to *share* with others the solipsistic egotism of their stupid pleasure. Freud already knew about the link between narcissism and
5:45 PM Apr 17th

1150. immersion in a crowd," which is exactly what Facebook is about. Instead of the encounter of the Two, notes Zizek, which "transubstantiates
5:46 PM Apr 17th

1151. idiotic masturbatory enjoyment into an event proper...the very dimension of otherness is cancelled: one does it with oneself." In the Armani
5:48 PM Apr 17th

1152. ads, and the masturbate-a-thon (along with sex tapes, where rather than fucking, people watch themselves fuck), people celebrate their own
5:49 PM Apr 17th

1153. bodies rather than the body of another; look at how their bodies look next to other bodies. Other bodies become mirrors for our bodies. A
5:51 PM Apr 17th

1154. way to see more of your own body. To get off on yourself. One split into two. Me looking at me. Me wanting me. Me immersed in me. Desire for
5:52 PM Apr 17th

1155. others has been replaced by desire for oneself. "I always think everyone's looking at me," notes the initially narcis-sistic Cleo, in Agnès
5:53 PM Apr 17th

1156. Varda's *Cleo from 5 to 7*, "but I only look at myself."
5:54 PM Apr 17th

1157. Julia in *Julia* (2008) is everything we didn't know about Gloria in *Gloria* (1980).
11:19 PM Apr 18th

1158. As with all of Michael Haneke's films, fantasy and reality collide. *The Piano Teacher's* stunning achievement is to study where Erika's fantasy
4:37 PM Apr 19th

1159. (masochism) ends and Walter's abuse (sadism) begins. To not conflate (the way that *Downloading Nancy* and *Antichrist* conflate) Erika's desires with
4:38 PM Apr 19th

1160. Walter's rage and misogyny. By the end of the film, Walter is not *playing* a rapist, or acting out Erika's carefully ordained rape fantasy.
4:39 PM Apr 19th

1161. He *is* a rapist, acting out his *own* desires. In an essay on *The Piano Teacher*, John Champagne writes that *"The Piano Teacher* is about the
4:40 PM Apr 19th

1162. impossibility of female desire…a feminist film in that it emphasizes how patriarchal culture renders female desire impossible." The rape
4:41 PM Apr 19th

1163. scene is therefore no longer a "rape scene"—a dramatization of commissioned pain as Erika's envisioned and penned it. Haneke's schema of sexual
4:42 PM Apr 19th

1164. politics meticulously shows that the controlled fantasy of rape isn't the same thing as the spontaneous and violent reality of *being* raped.
4:43 PM Apr 19th

1165. In his essay, Champagne refers to Delueze's theory on masochism and sadism, which, according to Delueze, "are not 'complementary' perversions,
4:44 PM Apr 19th

1166. but rather constitute two different perversions with different aims, aesthetics, and ends.'" In the end, Walter obliterates the power of
4:46 PM Apr 19th

1167. Erika's masochism through his own sadistic desire to inflict pain.
4:47 PM Apr 19th

1168. In movies that take place in hot climates, a man can be characterized by the fact that rather than taking off his shirt, or wearing less of
11:56 PM Apr 20th

1169. a shirt, he keeps the shirt he has on and sweats through it. There is personality in this.
11:57 PM Apr 20th

1170. Why does something strike you, then not strike you? Not strike you, then strike you? I'm talking about movies.
6:27 PM Apr 21st

1171. "That's why I make movies: I see something which I do not understand and then I make a film in order to comprehend it." Kim Ki-Duk
10:23 AM Apr 22nd

1172. People never end up together in Sydney Pollack's movies. There is no untying (dénouement). Ever. Even in the last film before his death.
11:01 PM Apr 23rd

1173. Catherine Breillat likes a crashing surf. *Anatomy of Hell, Sex is Comedy*. Is it because, as Kate Durbin writes in her poetry collection *The*
11:32 PM Apr 24th

1174. *Ravenous Desire,* "The sea is always bigger, far wider than flesh?"
11:33 PM Apr 24th

1175. *Fever Pitch*—both the British version and the American version—is about a man's all-encompassing love and obsession with football. But
10:49 PM Apr 25th

1176. Paul's football fever isn't humanizing, as the film tries to show. It's an example of male monomania.
10:50 PM Apr 25th

1177. Both *Marnie* and *Red Desert* were made in 1964. Both feature "neurotic" women.
11:29 PM Apr 26th

1178. When a potential female love interest tells Jacob (the youngest character in *Hot Tub Time Machine,* and who unlike the rest of the "80s" cast,
5:37 PM Apr 27th

1179. has no ties to or knowledge of the past) to just track her down and "find her" (a throw back to the days when cell phones and email weren't
5:38 PM Apr 27th

1180. de rigeur) by moaning, "that sounds exhausting," Jacob's reaction says more about the past and the present than any other moment in the time-
5:39 PM Apr 27th

1181. reflexive film because it tells us something about the way cinema preserves and uses a defunct past to depict the present. How it creates
5:40 PM Apr 27th

1182. the pretense and illusion of continuity; of an enduring social value. In the past, pursuit was still tied to life. To wanting to know
5:41 PM Apr 27th

1183. something or someone. And this is what we've lost. This is what's no longer part of the fabric of daily life. This is what's trapped in
5:42 PM Apr 27th

1184. time. In celluloid. But *Hot Tub Time Machine* balks at time. Is flippant about the effort it requires to actually live life. Jacob and his
5:43 PM Apr 27th

1185. generation find any kind of "searching" (effort)—for love, knowledge, oneself, etc—absurd and "exhausting." They give up before they even
5:44 PM Apr 27th

1186. start, which makes everything mean less, or not at all, for meaning is circumvented altogether. But while most movies continue to pretend as
5:45 PM Apr 27th

1187. though the things that once mattered still matter, *Hot Tub Time Machine* doesn't travel back in time. Rather, it breaks the illusory cinema-
5:46 PM Apr 27th

1188. life continuum by introducing a cinematic cynicism that matches real life cynicism.
5:47 PM Apr 27th

1189. Sometimes movies about the past are as futuristic as movies about the future, especially the old ones.
10:02 PM Apr 28th

1190. "React to what's happening." *Code Unknown*
11:54 PM Apr 29th

1191. "The Gulf Leak is 5 times worse than estimated." Oil is karma, or as Tarkovsky puts it in *Solaris*, "The ocean is a thinking substance."
7:08 PM May 1st

1192. "If an oil well is too far beneath the sea to be plugged when something goes wrong, it's too deep to be drilled in the first place." Bob Herbert
7:56 PM May 31st

1193. "I don't know why, but I hate all comparisons involving oil." *L'Avventura*
9:01 PM May 31st

1194. Joe Dallesandro's body in Paul Morrissey's 398-minute trilogy (*Flesh, Trash, Heat*) is like Warhol's 8-hour film of the Empire State
10:41 PM June 1st

1195. building. You can tune in or tune out at any point and Joe's static flesh, like the Empire State building, will still be there. Even
10:42 PM June 1st

1196. as some new flesh replaces it, Joe's body remains a beacon. His flesh endures through film as an edifice of desire.
10:43 PM June 1st

1197. As Guy Montag (Oskar Werner) starts to become less mechanized in Truffaut's *Fahrenheit 451*, he mysteriously loses his ability to fly up and
1:40 AM June 2nd

1198. down the firemen's pole. He develops what the Fire Captain calls "a pole problem." When gravity is added to life, to existence, through
1:42 AM June 2nd

1199. reading, a mindless levity is sacrificed. Montag starts to fill up. To weigh something. Having to take the stairs becomes a
1:43 AM June 2nd

1200. direct metaphor for the daily weight life requires.
1:44 AM June 2nd

Films and books

(in order of appearance):

1. *Kramer vs. Kramer*, Robert Benton, 1979, USA.
2. *Eastern Promises*, David Cronenberg, 2007, USA.
3. *A History of Violence*, David Cronenberg, 2005, USA.
4. *Rachel Getting Married*, Jonathan Demme, 2008, USA.
5. *Let the Right One In*, Tomas Alfredson, 2008, Sweden.
6. Jong, Erica. *Seducing The Demon: Writing for My Life.* Tarcher, 2007.
7. *The Savages*, Tamara Jenkins, 2007, USA.
8. *The Oprah Winfrey Show* (TV), 1986-present, USA.
9. *Wendy and Lucy*, Kelly Reichardt, 2008, USA.
10. *Love at Large*, Alan Rudolph, 1990, USA.
11. *Vertigo* (1958) Alfred Hitchcock, USA.
12. *The Castle (Das Schloss)*, Michael Haneke, 1997, Germany.
13. *Lars and The Real Girl*, Craig Gillespie, 2007, USA.
14. *Half Nelson*, Ryan Fleck, 2006, USA.
15. *The Beaches of Agnès (Les plages d'Agnès)*, Agnès Varda, 2008, France.
16. *A Very Long Engagement (Un long dimanche de fiancailles)*, Jean-Pierre Jeunet, 2004, France.
17. *Broken English*, Zoe R. Cassavetes, 2007, USA.
18. *Roman Polanski: Wanted and Desired*, Marina Zenovich, 2008, USA.
19. *My Winnipeg*, Guy Maddin, 2007, USA.
20. *Eyes Wide Side*, Stanley Kubrick, 1999, USA.
21. *Superbad*, Greg Mottola, 2007, USA.
22. *They Shoot Horses, Don't They*, Sydney Pollack, 1969, USA.
23. *Talking Heads: Stop Making Sense*, Jonathan Demme, 1984, USA.
24. *Palindromes*, Todd Solondz, 2005, USA.

25. *Juno*, Jason Reitman, 2007, USA.

26. *Knocked Up*, Judd Apatow, 2007, USA.

27. *Desperate Housewives*, Marc Cherry (TV), 2004-present, USA.

28. *Next Stop, Greenwich Village*, Paul Mazursky, 1976, USA.

29. *Milk*, Gus Van Sant, 2008, USA.

30. S. Bajko, Matthew. "Castro Set for Movie Makeover." *Bay Area Reporter* (December 27, 2007).

31. *Heaven Can Wait*, Warren Beatty & Buck Henry, 1978, USA.

32. *Being There*, Hal Ashby, 1979, USA.

33. *Reds*, Warren Beatty, 1981, USA.

34. *Cutter's Way*, Ivan Passer, 1981, USA.

35. *Love Story*, Arthur Hiller, 1970, USA.

36. *Jaws*, Steven Spielberg, 1975, USA.

37. *Taxi Driver*, Martin Scorsese, 1976, USA.

38. *Rambo: First Blood*, Ted Kotcheff, 1982,USA.

39. *Fatal Attraction*, Adrian Lyne, 1987, USA.

40. *Big*, Penny Marshall, 1988, USA.

41. *Total Recall*, Paul Verhoeven, 1990, USA.

42. *Speed*, Jan De Bont, 1994, USA.

43. *Heat*, Michael Mann, 1995, USA.

44. *Crash*, Paul Haggis, 2004, USA.

45. *Caché*, Michael Haneke, 2005, France.

46. Gogol, Nikolai. *The Diary of a Madman, The Government Inspector, and Selected Stories*. Penguin Classics, 2006.

47. *Irma Vep*, Olivier Assayas, 1996, France.

48. *Les Vampires*, Louis Feuillade, 1915, France.

49. *The Tracey Fragments*, Bruce McDonald, 2007, USA.

50. *L'Avventura (The Adventure)*, Michelangelo Antonioni, 1960, Italy.

51. *Point Blank*, John Boorman, 1967, USA.

52. *The Wrestler*, Darren Aronofsky, 2008, USA.

53. O'Brien, Geoffrey. *The Phantom Empire: Movies in the Mind of the 20th Century*. W. W. Norton & Company, 1995.

54. *Rambo*, Sylvester Stallone, 2008, USA.
55. *Happy-Go-Lucky*, Mike Leigh, 2008, UK.
56. *Julia*, Erick Zonca, 2008, USA.
57. Wood, Robin. "Michael Haneke: Beyond Compromise." *CineAction*. Issue 73-4 (Summer, 2007).
58. *Bad Timing*, Nicolas Roeg, 1980, UK.
59. *The Interpreter*, Sydney Pollack, 2005, USA.
60. *Black Window*, Bob Rafelson, 1987, USA.
61. *The Insider*, Michael Mann, 1999, USA.
62. *60 Minutes* (TV), 1968-present, USA.
63. *The Last Tycoon*, Elia Kazan, 1976, USA.
64. *Harper's Island*, Ari Schlossberg (TV), 2009, USA.
65. *The Chase*, Arthur Penn, 1966, USA.
66. *The Pick-Up Artist*, James Toback, 1987, USA.
67. Schulman, Sarah. *The Child*. Arsenal Pulp Press, 2008.
68. *Caged Heat*, Jonathan Demme, 1974, USA.
69. *Changeling*, Clint Eastwood, 2008, USA.
70. *Wanted*, Timur Bekmambetov, 2008, USA.
71. *The Witches of Eastwick*, George Miller, 1987, USA.
72. *Superman*, Richard Donner, 1978, USA.
73. *Becoming Jane*, Julian Jarrold, 2007, UK.
74. *The Curious Case of Benjamin Button*, David Fincher, 2008, USA.
75. *Witches*, Nicolas Roeg, 1990, UK.
76. *The China Syndrome*, James Bridges, 1979, USA.
77. *There Will Be Blood*, Paul Thomas Anderson, 2007, USA.
78. *The Shining*, Stanley Kubrick, 1980, USA.
79. *Two Lovers*, James Gray, 2008, USA.
80. *Code Unknown: Incomplete Tales of Several Journeys (Code inconnu: Récit incomplet de divers voyages)*, Michael Haneke, 2000, France.
81. *Inside The Actor's Studio*, James Lipton (TV), 1994-present, USA.
82. Glatt, John. *Lost in Hollywood: The Fast Times and Short Life of*

River Phoenix. St Martins Mass Market Paper, 1996.

83. *The Comedians*, Peter Glenville, 1967, UK.
84. *Marooned (Space Travelers)*, John Sturges, 1969, USA.
85. *Lilith*, Robert Rossen, 1964, USA.
86. *Gran Torino*, Clint Eastwood, 2008, USA.
87. *As Good as It Gets*, James L. Brooks, 1997, USA.
88. *The History Boys*, Nicholas Hytner, 2006, UK.
89. *The Sugarland Express*, Steven Spielberg, 1974, USA.
90. *Gas Food Lodging*, Allison Anders, 1992, USA.
91. Wood, Robin. *Hollywood: From Vietnam to Reagan*. Columbia University Press, 1986.
92. Didion, Joan. *Slouching Towards Bethlehem*. Farrar, Straus and Giroux, 2008.
93. *Pola X*, Leos Carax, 2000, France.
94. *Eternal Sunshine of the Spotless Mind*, Michel Gondry, 2004, USA.
95. *Zabriskie Point*, Michelangelo Antonioni, 1970, USA.
96. *Ghosts of Girlfriends Past*, Mark Waters, 2009, USA.
97. *The Yakuza (Brotherhood of the Yakuza)*, Sydney Pollack, 1975, USA.
98. *Hannibal*, Ridley Scott, 2001, USA.
99. *La Mer (The sea, three symphonic sketches for orchestra)*, Claude Debussy, 1905, France.
100. *Eureka*, Nicolas Roeg, 1983, UK.
101. *Don't Look Now*, Nicolas Roeg, 1973, UK.
102. *Whore*, Ken Russell, 1991, USA.
103. *Luna*, Bernado Bertolucci, 1979, Italy.
104. *Ash Wednesday*, Larry Peerce, 1973, USA.
105. *Notes On a Scandal*, Richard Eyre, 2006, UK.
106. *North by Northwest*, Alfred Hitchcock, 1959, USA.
107. *Turner Classic Movies* (TV), 1994-present, USA.
108. *Less Than Zero*, Marek Kanievska, 1987, USA.
109. *The Informers*, Gregor Jordan, 2008, USA.
110. *Against All Odds*, Taylor Hackford, 1984, USA.

111. *Out of the Past*, Jacques Tourneur, 1947, USA.

112. *Altered States*, Ken Russell, 1980, USA.

113. *Valentino: The Last Emperor*, Matt Tyrnauer, 2008, USA.

114. *8 1/2* (Otto e Mezzo), Federico Fellini, 1963, Italy.

115. *8 ½ Women*, Peter Greenaway, 1999, UK.

116. *The Stepford Wives*, Bryan Forbes, 1975, USA.

117. *Night at the Museum 2: Battle of the Smithsonian*, Shawn Levy, 2009, USA.

118. Kosinki, Jerzy. *Steps*. Grove Press, 1997.

119. *The Bad and the Beautiful*, Vincente Minnelli, 1952, USA.

120. *Pan's Labyrinth* (*El Laberinto del Fauno*), Guillermo del Torro, 2006, Spain.

121. *The Spirit of the Beehive* (*El Espíritu de la Colmena*), Victor Erice, 1973, Spain.

122. Harris, Mark. *Scenes from a Revolution: The Birth of the New Hollywood*. Canongate Books, 2008.

123. Brooks, Xan. "Horrible Histories." Guardian.co.uk. (May 18, 2005).

124. *The Lives of Others* (*Das Leben der Anderen*), Florian Henckel von Donnersmarck, 2007, Germany.

125. Nelson, Maggie. *Bluets*. Wave Books, 2009.

126. *The Sound of Music*, Robert Wise, 1965. UK.

127. *The Passenger* (Professione: Reporter), Michelangelo Antonioni, 1975, USA.

128. *Gallipoli*, Peter Weir, 1981, Australia.

129. *Safe*, Todd Haynes, 1995, USA.

130. *Antichrist*, Lars von Trier, 2009, Denmark.

131. *Downloading Nancy*, Johan Renck, 2008, USA.

132. Hayward, Paul. "Boxing: Tyson's complicated world." *Telegraph.co.uk* (May 1, 2002).

133. *The Black Girl of* (La Noire De...), Ousmane Sembene, 1966, France/Senegal.

134. *The Piano Teacher* (*La Pianiste*), Michael Haneke, 2005, France

135. *The Last Mistress*, Catherine Breillat, 2007, France.

136. *The Black Dahlia*, Brian De Palma, 2006, USA.

137. *The Eyes of Laura Mars*, Irvin Kershner, 1978, USA.

138. Fischer, Lucy and Landy, Marcia. "Eyes of Laura Mars: A Binocular Critique," in *American Horrors: Essays on The Modern American Horror Film*, edited by Gregory A. Waller, 62-78. University of Illinois Press, 1987.

139. *Touch of Evil*, Orson Welles, 1958, USA.

140. *Kate & Leopold*, James Mangold, 2001, USA.

141. *Before the Devil Knows You're Dead*, Sidney Lumet, 2007, USA.

142. *Mean Streets*, Martin Scrosese, 1973, USA.

143. *La Strada*, Federico Fellini, 1954, Italy.

144. *Raging Bull*, Martin Scorsese, 1980, USA.

145. *It Might Get Loud*, Davis Guggenheim, 2008, USA.

146. *The House of The Devil*, Ti West, 2009, USA.

147. *Stardust Memories*, Woody Allen, 1980, USA.

148. Suzanne, Moore. *Looking For Trouble*. Serpents Tail, 1992.

149. *Inland Empire*, David Lynch, 2006, USA.

150. *Anatomy of Hell (Anatomie de L'Enfer)*, Catherine Breillat, 2004, France.

151. *Michael Jackson: The Trial and Triumph of the King of Pop*, Wilson Ebiye, Pear Jr., 2009, USA.

152. *Cries and Whispers*, Ingmar Bergman, 1972, Sweden.

153. *Herb & Dorothy*, Megumi Sasaki, 2008, USA.

154. *2012*, Roland Emmerich, 2009, USA.

155. Miller, Jenny. "What the Stars and Director of *2012* Think About *2012*." *Cinematical.com* (November 3, 2009).

156. The Smiths. *Hatful of Hollow*. "Please, Please, Please Let Me Get What I Want." 1984, UK.

157. Schwartz, Delmore. *In Dreams Begin Responsibilities and Other Stories*. New Directions Publishing Corporation, 1978.

158. *The Fisher King*, Terry Gilliam, 1991, USA.

159. Brown, Rebecca and Kiefer, Nancy. *Woman in Ill-Fitting*

Wig. Tarpaulin Sky, 2005.

160. Hardy, Ernest. "For Colored Girls: Taboo Buster or Tool of the Oppressor?" *LA Weekly* (November 13-19, 2009).

161. *Say Anything*, Cameron Crowe, 1989, USA.

162. *The Wizard of Oz*, Victor Fleming, 1939, USA.

163. *Scream*, Wes Craven, 1996, USA.

164. *Flesh*, 1968, Paul Morrissey, USA.

165. *Trash*, Paul Morrissey, 1970, USA.

166. *Heat*, Paul Morrissey, 1072, USA.

167. *Teorema*, Pier Paolo Pasolini, 1968, Italy.

168. Harbison, Robert. *Reflections on Baroque*. University of Chicago Press, 2003.

169. *The Man Who Knew Too Much*, Alfred Hitchcock, 1956, USA.

170. Frey, James. *A Million Little Pieces*. Anchor, 2005.

171. "A Million Little Lies: Exposing James Frey's Fiction Addiction." *The Smoking Gun* (January 8, 2006), http://www.thesmokinggun.com/jamesfrey/0104061jamesfrey6.html

172. *F for Fake* (*?: About Fakes*), Orson Welles, 1973, France.

173. St. Vincent. *Actor*. "Actor out of Work," 2009, USA.

174. *THX 1138*, George Lucas, 1971, USA.

175. *Crosby Street*, Judy Saslow, 1975, USA.

176. *Los Angeles Plays Itself*, Thom Anderson, 2004, USA.

177. *Saturday Night Live*, Loren Michaels (TV), 1975-present, USA.

178. Rushkoff, Douglas. *Life, Inc.: How the World Became a Corporation and How to Take it Back*. Random House, 2009.

179. Howe, Fanny. *The Wedding Dress: Meditations on Word and Life*. University of California Press, 2003.

180. *Frantic*, Roman Polanski, 1988, USA.

181. *The Elephant Man*, David Lynch, 1980, USA.

182. *Vanishing Point*, Richard C. Sarafian, 1971, USA.

183. *Carrie*, Brian De Palma, 1976, USA.

184. *Dressed to Kill*, Brian De Palma, 1980, USA.

185. *Yves St. Laurent: His Life and Times*, David Teboul, 2002, France.
186. *Raising Arizona*, Joel Coen, 1987, USA.
187. *Sleepless in Seattle*, Nora Ephron, 1993, USA.
188. *Return of the Secaucus 7*, John Sayles, 1980, USA.
189. *Bed and Board* (*Domicile Conjugal*), François Truffaut, 1970, France.
190. *The 400 Blows* (*Les quatre cents coups*), François Truffaut, 1959, France.
191. *The Usual Suspects*, Bryan Singer, 1995, USA.
192. *Citizen Kane*, Orson Welles, 1941, USA.
193. *The Mirror*, Andrei Tarkovsky, 1975, Russia.
194. *The Ice Storm*, Ang Lee, 1997, USA.
195. *Good Hair*, Jeff Stilson, 2009, USA.
196. Radiohead. *Kid A*. "Idioteque," 2000, UK.
197. *Chinatown*, Roman Polanski, 1974, USA.
198. *The Secretary*, Steven Shainberg, 2002, USA.
199. *Lethal Weapon*, Richard Donner, 1987, USA.
200. *Edge of Darkness*, Martin Campbell, 2009, USA.
201. *Cape Fear*, J. Lee Thompson, 1962, USA.
202. *Cape Fear*, Martin Scorsese, 1991, USA.
203. *Brodre*, Susanne Bier, 2005, Denmark.
204. *I Am Sam*, Jessie Nelson, 2001, USA.
205. *Red Desert*, Michelangelo Antonioni, 1964, Italy.
206. *The Girlfriend Experience*, Steven Soderbergh, 2009, USA.
207. *She's the One*, Edward Burns, 1996, USA.
208. *Adam & Steve*, Craig Chester, 2005, USA.
209. *The Road*, John Hillcoat, 2009, USA.
210. *Kicking and Screaming*, Noah Baumbach, 1995, USA.
211. *Mr. Jealousy*, Noah Baumbach, 1998, USA.
212. *Greenberg*, Noah Baumbach, 2009, USA.
213. *Broadway Danny Rose*, Woody Allen, 1984, USA.
214. *Brothers*, Jim Sheridan, 2009, USA.
215. *America the Beautiful*, Darryl Roberts, 2007, USA

216. Farrow, Mia. *What Falls Away: A Memoir*. New York: Doubleday, 1997.

217. Robertson, Nan. "Joseph Levine, A Towering Figure in Movie Making." *The New York Times* (August 1, 1987).

218. *Food, Inc.*, Robert Kenner, 2008, USA.

219. Depaulo, Lisa. "Good Girl Gone Badass." *GQ* (January, 2010).

220. *Avatar*, James Cameron, 2009, USA.

221. *Nine*, Rob Marshall, 2009, USA.

222. *Nosferatu: A Symphony of Terror* (*Nosferatu, eine Symphonie des Grauens*), F.W. Murnau, 1922, Germany.

223. *An Officer and a Gentlemen*, Taylor Hackford, 1982, USA.

224. Hustvedt, Siri. *What I Loved: A Novel*. Picador, 2004.

225. *Flesh for Frankenstein*, Paul Morrissey, 1973, USA.

226. Bordo, Susan. *Twilight Zones: The Hidden Life of Cultural Images from Plato to O.J.* University of California Press, 1999.

227. *The American Nightmare*, Adam Simon, 2000, USA.

228. *Superstar: The Karen Carpenter Story*, Todd Haynes, 1987, USA.

229. Schulman, Sarah. *Stagestruck: Theater, AIDS, and the Marketing of Gay America*. Duke University Press, 1998.

230. Scott, A.O. "There Will Be Lingerie (Singing, Too)." *The New York Times* (December 18, 2009).

231. *Femme Fatale*, Brian De Palma, 2002, USA.

232. Wood, Robin. "The Little Space In Between: Preliminary Notes on Before Sunrise." *CineAction*. Issue 41 (October, 1996).

233. *Before Sunrise*, Richard Linklater, 1995, USA.

234. *La Jetée* (*The Pier*), Chris Marker, 1961, France.

235. *Sans Soleil* (*Without Sun*), Chris Marker, 1982, France.

236. *Court-circuit* (*le magazine*), Luc Lagier, (TV), 2001, France.

237. *E.T.: The Extra-Terrestrial*, Steven Spielberg, 1982, USA.

238. *My Fair Lady*, George Cukor, 1964, USA.

239. *Funny Girl*, William Wyler, 1968, USA.

240. *What's Up, Doc?*, Peter Bogdanovich, 1972, USA.

241. *The Way We Were*, Sydney Pollack, 1973, USA.

242. *The Prince of Tides*, Barbra Streisand, 1991, USA.

243. *The Mirror Has Two Faces*, Barbra Streisand, 1996, USA.

244. *Meet the Fockers*, Jay Roach, 2004, USA.

245. Yeah Yeah Yeahs. *It's Blitz!*. "Hysteric," 2009, USA.

246. *Red (Trois Couleurs: Rouge)*, Krzysztof Kieslowski, 1994, France.

247. *Funny People*, Judd Apatow, 2009, USA.

248. *Serious Man*, Ethan and Joel Coen, 2009, USA.

249. *Broadcast News*, James L. Brooks, 1987, USA.

250. *Pretty in Pink*, Howard Deutch, 1986, USA.

251. *Grace Is Gone*, James C. Strouse, 2007, USA.

252. *The Visitor*, Thomas McCarthy, 2007, USA.

253. *...And Justice for All*, Norman Jewison, 1979, USA.

254. *The Godfather*, Francis Ford Coppola, 1972, USA.

255. *Serpico*, Sidney Lumet, 1973, USA.

256. *The Panic in Needle Park*, Jerry Schatzberg, 1971, USA.

257. *Scarface*, Brian De Palma, 1983, USA.

258. *Sea of Love*, Harold Becker, 1989, USA.

259. *Scent of a Woman*, Martin Brest, 1992, USA.

260. *The Devil's Advocate*, Taylor Hackford, 1997, USA.

261. *Any Given Sunday*, Oliver Stone, 1999, USA.

262. *Sex Is Comedy (Scenes Intimes)*, Catherine Breillat, 2002, France.

263. *Shattered Glass*, Billy Ray, 2003, USA.

264. Martijn Van Berkum, Scaffolding Project blog. "Shattered Glass" (May 27, 2009).

265. *Everything's Fine*, Kirk Jones, 2009, USA.

266. *The Wedding Party*, Brian De Palma, 1969, USA.

267. *Wal-Mart: The High Cost of Low Price*, Robert Greenwald, 2005, USA.

268. *Inside Deep Throat*, Fenton Bailey, Randy Barbato, USA.

269. Finch, Christopher. *Pop Art: Object and Image*. EP Dutton,

1968.

270. *Barry Lyndon*, Stanley Kubrick, 1975, UK.

271. *The Driver*, Walter Hill, 1978, USA.

272. *Love Streams*, John Cassavetes, 1984, USA.

273. *Opening Night*, John Cassavetes, 1977, USA.

274. *Gloria*, John Cassavetes, 1980, USA.

275. *Husbands: A Comedy About Life, Death and Freedom*, John Cassavetes, 1970, USA.

276. *Minnie and Moskowitz*, John Cassavetes, 1971, USA.

277. Britton, Andrew. *Britton on Film: The Complete Film Criticism of Andrew Britton*. Edited by Barry Keith Grant. Wayne State University Press, 2008.

278. Brown, Rebecca. *American Romances: Essays*. City Lights Publishers, 2009.

279. Wilde, Oscar. "The Decay of Lying: An Observation," 1889.

280. *The Grifters*, Stephen Frears, 1990, USA.

281. *Walkabout*, Nicolas Roeg, 1971, UK.

282. *2001: A Space Odyssey*, Stanley Kubrick, 1968, USA/UK.

283. *The Limits of Control*, Jim Jarmusch, 2008, USA.

284. *Broken Flowers*, Jim Jarmusch, 2005, USA.

285. *The King of Marvin Gardens*, Bob Rafelson, 1972, USA.

286. *Helvetica*, Gary Hustwit, 2007, USA.

287. *The Lady from Shanghai,* Orson Welles, 1948, USA.

288. *The Big Sleep*, Howard Hawks, 1946, USA.

289. *The Three Faces of Eve*, Nunnally Johnson, 1957, USA.

290. *The Cabinet of Dr. Caligari*, Robert Wiene, 1919, Germany.

291. *Psycho*, Alfred Hitchcock, 1960, USA.

292. *The Conformist (Il Conformista)*, Bernardo Bertolucci, 1970, Italy.

293. *Slacker*, Richard Linklater, 1991, USA.

294. *Rebel Without a Cause*, Nicholas Ray, 1955, USA.

295. *East of Eden*, Elia Kazan, 1955, USA.

296. Hoberman, J. "Detective Comics: Showbiz Noir Investigates TV Superman's Real-life Tragedy." *The Village Voice* (August

29, 2006).

297. *Andrei Rublev* (*Andrei Rublyov*), Andrei Tarkovsky, 1966, Russia.

298. *The Gospel According to St. Matthew* (*Il Vangelo Secondo Matteo*), Pier Paolo Pasolini, 1964, Italy.

299. Tolstoy, Leo. *The Gospel in Brief*. White Crow Books, 2010.

300. *Rage*, Sally Potter, 2009, UK.

301. *Hollywoodland*, Allen Coulter, 2006, USA.

302. *Whatever Happened to Baby Jane?*, Robert Aldrich, 1962, USA.

303. Svadjian, Armen. "A Life in Film Criticism: Robin Wood at 75." *Your Flesh Magazine*, (November 9, 2006).

304. *Medium*, Glenn Gordon Caron (TV), 2005-present, 2010.

305. Böll, Heinrich. *The Clown*. Melville House, 2010.

306. *Saboteur*, Alfred Hitchcock, 1942, USA.

307. *The Dark Knight*, Christopher Nolan, 2008, USA.

308. *Good Morning America* (TV), 1975-present, USA.

309. *Black White + Gray: A Portrait of Sam Wagstaff and Robert Mapplethorpe*, James Crump, 2007, USA.

310. *The Human Face*, James Erskine, David Stewart, 2001, UK.

311. *Misery*, Rob Reiner, 1990, USA.

312. Mark Fisher, k-punk blog, "They Killed Their Mother: *Avatar* As Ideological Symptom." (January 6, 2010).

313. Giovanni Tiso, Bat, Bean, Beam: A Weblog on Memory and Technology, "Haiti, in 3D." (January 18, 2010).

314. *Soldier Blue*, Ralph Nelson, 1970. USA.

315. *The Bicycle Thief* (*Ladri di biciclette*), Vittorio De Sica, 1948, Italy.

316. *I Love You, Man*, John Hamburg, 2009, USA.

317. *Pineapple Express*, David Gordon Green, 2008, USA.

318. *Pickpocket*, Robert Bresson, 1959, France.

319. Hoberman, J. "States of Grace: Two More Master Classes in Sound and Image from a Giant of Cinema." *The Village Voice* (September 27, 2005).

320. *Man Push Cart*, Ramin Bahrani, 2005, USA.

321. Mrs. Soffel, *Gillian Armstrong*, 1984, USA.

322. *The Machinist*, Brad Anderson, 2004, USA.

323. *Insomnia*, Christopher Nolan, 2002, USA.

324. *All About Eve*, Joseph L. Mankiewicz, 1950, USA.

325. *Head-On*, Fatih Akin, 2004, Germany.

326. *The Awful Truth*, Leo McCarey, 1937, USA.

327. Baudrillard, Jean. *De la seduction*. Editions Galilee: Paris, 1979.

328. *Moon*, Duncan Jones, 2009, USA.

329. *It's Alive*, Larry Cohen, 1974, USA.

330. *Confessions of A Shopaholic*, P.J. Hogan, 2009, USA.

331. *Keeping Up with the Kardashians*, Eliot Goldberg, Ryan Seacrest (TV), 2007-present, USA.

332. *Solaris (Solyaris)*, Andrei Tarkovsky, 1972, Russia.

333. *Ugetsu (Ugetsu Monogatari / Tales of Ugetsu / Tales of a Pale and Mysterious Moon After the Rain)*, Kenji Mizoguchi, 1953, Japan.

334. *Stalker*, Andrei Tarkovsky, 1979, Russia.

335. Tupitsyn, Masha. *Beauty Talk & Monsters*, Semiotext(e), 2007.

336. *Visual Acoustics: The Modernism of Julius Shulman*, Eric Bricker, 2008, USA.

337. *Fay Grim*, Hal Hartley, 2006, USA.

338. *Who's That Knocking at My Door? (I Call First)*, Martin Scorsese, 1967, USA.

339. *Easy Virtue*, Stephan Elliot, 2008, UK.

340. *Paris, je t'aime*, Frederic Auburtin, Alfonso Cuarón, Emmanuel Benbihy, Gus Van Sant, Ethan Coen, Joel Coen, Wes Craven, Alexander Payne, Olivier Assayas, 2006, France.

341. *New York, I Love You*, Yvan Attal, Allen Hughes, Natalie Portman, Shekhar Kapur, Joshua Marston, Shunji Iwai, Fatih Akin, Mira Nair, Brett Ratner, Jiang Wen, 2008, USA.

342. *Conversations with Other Women*, Hans Canosa, 2006, USA.

343. *The Karate Kid*, John J. Avildsen, 1984, USA.

344. *Brief Encounter*, David Lean, 1945, UK.

345. Brecht, Bertolt. "The Interrogation of the Good."

346. Aloni, Udi. "Judith Butler: As a Jew, I was taught it was ethically imperative to speak up." *Haaretz.com* (February 2, 2010).

347. Zizek, Slavoj. *Violence*. Picador, 2008.

348. *Cool Hand Luke*, Stuart Rosenberg, 1967, USA.

349. *Fail-Safe*, Sidney Lumet, 1964, USA.

350. *Radio Bikini*, Robert Stone, 1987, USA.

351. *Shutter Island*, Martin Scorsese, 2010, USA.

352. *Medium Cool*, Haskell Wexler, 1969, USA.

353. *Children of Men*, Alfonso Cuarón, 2006,

354. Cuarón, Alfonso, http://www.impactservices.net.au/movies/childrenofmen.htm

355. Hubbard, L. Ron. "The Technique 88 Lecture on Overts and Withholds" (July, 1963).

356. Ginsberg, Allen. *Howl*. City Lights Publishers, 2001.

357. *Sisters*, Brian De Palma. 1973, USA.

358. Yeah Yeah Yeahs. *It's Blitz!*. "Soft Shock," 2009, USA.

359. Sarsgaard, Peter. *NYTimes.com*. January 20, 2008.

360. *Five Easy Pieces*, Bob Rafelson, 1970, USA.

361. Faludi, Susan. *Backlash: The Undeclared War Against American Women*. Three Rivers Press; 15 Anv edition, 2006.

362. *The Arrangement*, Elia Kazan, 1969, USA.

363. *The Swimmer*, Frank Perry, 1968, USA.

364. Stern, Marlow. "Michael Douglas is a Solitary Man!" *Manhattan Movie Magazine* (May 22, 2010).

365. *Marley & Me*, David Frankel, 2008, USA.

366. *The Tao of Steve*, Jenniphr Goodman, 2000, USA.

367. *Lonesome Jim*, Steve Buscemi, 2005, USA.

368. *Up in the Air*, Jason Reitman, 2009, USA.

369. Schulman, Sarah. *Ties That Bind: Familial Homophobia and Its Consequences*. New Press, 2009.

370. Fromm, Erich. *The Art of Loving*. Harper Perennial Modern Classics, 2006.

371. *The Marriage Ref*, Jerry Seinfeld (TV), 2010-present, USA.

372. *Fantastic Mr. Fox*, Wes Anderson, 2009, USA.

373. hooks, bell. *Outlaw Culture Resisting Representations*. Routledge, 1994.

374. *Love on the Run*, (*L'amour en fuite*), François Truffaut, 1979, France.

375. *Surviving Desire*, Hal Hartley, 1991, USA.

376. *Fahrenheit 451*, François Truffaut, 1966, USA.

377. Steven Boone, Big Media Vandalism blog, "Sweet Lime and 'Sour Grapes': Armond White Conversation, Part III."' (December 18, 2007).

378. *Funny Games*, Michael Haneke, 1998, Germany.

379. *A Clockwork Orange*, Stanley Kubrick, 1971, USA.

380. *The Postman Always Rings Twice*, Bob Rafelson, 1981, USA.

381. *Blade Runner*, Ridley Scott, 1982, USA.

382. *Law & Order*, Dick Wolf (TV), 1990-2010, USA.

383. *Time After Time*, Nicholas Meyer, 1979, USA.

384. Neal, Rome. "Julianne Moore: Becoming Beautiful." The Early Show, (September 28, 2004).

385. *Night of the Living Dead*, George A. Romero, 1968, USA.

386. *A Single Man*, Tom Ford, 2009, USA.

387. *Dominick Dunne: After the Party*, Kristy de Garis, Timothy Jolley, 2008, USA.

388. *Benny's Video*, Michael Haneke, 1992, Germany.

389. *A Hundred and One Nights* (*Les Cent et Une Nuits de Simon Cinéma*), Agnès Varda, 1995, France.

390. *Dawn of the Dead* (Zombi), George A. Romero, 1978, USA.

391. *Manhunter* (Red Dragon: The Pursuit of Hannibal Lecter), Michael Mann, 1986, USA.

392. *Collateral*, Michael Mann, 2004, USA.

393. *The Proposal*, Anne Fletcher, 2009, USA.

394. Victor and Margarita Tupitsyn. *Moscow Partisan*

Conceptualism: Irina Nakhova and Pavel Pepperstein. London: Orel Art UK, 2010.

395. *Zombieland*, Ruben Fleischer, 2009, USA.

396. *Halloween*, John Carpenter, 1978, USA.

397. *Three Days of the Condor*, Sydney Pollack, 1975, USA.

398. *Out of Africa*, Sydney Pollack, 1985, USA.

399. Young, Molly. "Inference of the Presence of Desire." *This Recording* (February 8, 2008).

400. *The Maltese Falcon*, John Huston, 1941, USA.

401. *Hot Tub Time Machine*, Steve Pink, 2010, USA.

402. *Sex and the City 2*, Michael Patrick King, 2010, USA.

403. *Dynasty*, Esther Shapiro, Richard Shapiro (TV), 1981-1989, USA.

404. *Sahara*, Breck Eisner, 2005, USA.

405. *The Deep*, Peter Yates, 1977, USA.

406. *Hannah and Her Sisters*, Woody Allen, 1986, USA.

407. Kruger, Barbara. "The Globe Shrinks." Mary Boone Gallery, 2010, New York City.

408. *Pretty Persuasion*, Marcos Siega, 2005, USA.

409. *On the Waterfront*, Elia Kazan, 1954, USA.

410. *The Lovely Bones*, Peter Jackson, 2009, USA.

411. *The Exorcist*, William Friedkin, 1973, USA.

412. Ebert, Roger. "*The Lovely Bones*." *Chicago-Sun Times* (January 13, 2010).

413. *The Ugly Truth*, Robert Luketic, 2009, USA.

414. *Cleo from 5 to 7 (Cleo de 5 a 7)*, 1961, Agnès Varda, France.

415. Champagne, John. "Undoing Oedipus: Feminism and Michael Haneke's *The Piano Teacher*." *Bright Lights Film Journal*. Issue 36 (April, 2002).

416. Hummel, Volker. "Interview with Kim Ki-Duk." *Senses of Cinema*. Issue 19 (March-April, 2002).

417. Durbin, Kate. *The Ravenous Audience*. Black Goat, 2009.

418. *Fever Pitch*, David Evans, 1997, UK.

419. *Marnie*, Alfred Hitchcock, 1964, USA.

420. Herbert, Bob. "Our Epic Foolishness." *The New York Times* (May 31, 2010).
421. *Empire*, Andy Warhol, 1964, USA.

Contemporary culture has eliminated both the concept of the public and the figure of the intellectual. Former public spaces – both physical and cultural – are now either derelict or colonized by advertising. A cretinous anti-intellectualism presides, cheerled by expensively educated hacks in the pay of multinational corporations who reassure their bored readers that there is no need to rouse themselves from their interpassive stupor. The informal censorship internalized and propagated by the cultural workers of late capitalism generates a banal conformity that the propaganda chiefs of Stalinism could only ever have dreamt of imposing. Zer0 Books knows that another kind of discourse – intellectual without being academic, popular without being populist – is not only possible: it is already flourishing, in the regions beyond the striplit malls of so-called mass media and the neurotically bureaucratic halls of the academy. Zer0 is committed to the idea of publishing as a making public of the intellectual. It is convinced that in the unthinking, blandly consensual culture in which we live, critical and engaged theoretical reflection is more important than ever before.